IMAGES
of America

NEPTUNE
AND
SHARK RIVER HILLS

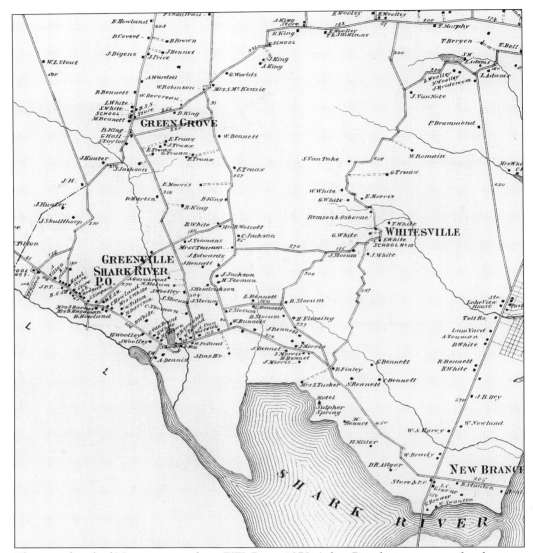

This is a detail of Neptune area from F.W. Beers 1873 Atlas. Population centers for the time are Greenville (Civil War-era name for Hamilton section), Whitesville (formerly known as Logantown), and Green Grove.

NEPTUNE
AND
SHARK RIVER HILLS

Evelyn Stryker Lewis

ARCADIA
PUBLISHING

Published by Arcadia Publishing
Charleston SC, Chicago IL, Portsmouth NH, San Francisco CA

Printed in the United States of America

Library of Congress Catalog Card Number: 2008922470

For all general information contact Arcadia Publishing at:
Telephone 843-853-2070
Fax 843-853-0044
E-mail sales@arcadiapublishing.com
For customer service and orders:
Toll-Free 1-888-313-2665

Visit us on the Internet at www.arcadiapublishing.com

Dedicated to my parents,
George Collier Stryker and Evelyn Ellsworth Stryker,
who in one childhood gave me happiness enough to last a lifetime.

CONTENTS

ACKNOWLEDGMENTS

My special appreciation to Neptune Township's first historian, Peggy Goodrich, who documented so much local history, leaving a lasting reference for understanding the people and the life which preceded us. My warm thanks to other special persons who have contributed their efforts to the writing of this book: Ellis Gilliam, knowledgeable splitter of hairs historical, who keeps me on my toes; Helen Pike for sharing Neptune-related leads during her research; Ann and Fred McCall for their Shark River Hills "safari"; and Dorns' Studios and Sure Service Photo's crew for their indispensable professional assistance. My appreciation to the following friends who saw to my finding the information I needed: Dana Bigelow, Peggy and Bob Burdge, JoAnne Collins, Garry Crawford, Mr. and Mrs. Bob Davis, Milton Edelman, Joseph Eid, Joe Ettore (Monmouth Co. Engineering Dept.), Billy Magill, Gene Marx, Elsie Morrison, Dolores Murray, Walter Scwartz, Billy Smith, plus Bill White and "Karen" of Welsh Farms.

Special kudos to Marian Bauman for reformatting the South Main Street map, to Naomi LeRiche for her computer counseling, and to Nancy Heydt for being both research assistant and project cheerleader when my own energies flagged.

INTRODUCTION

In the mid-1700s, 150 years before neighboring Asbury Park, Ocean Grove or Bradley Beach saw settlement, a small nucleus of homesteaders in today's western Neptune constituted one of the rare outposts of civilization amidst the coastal wilderness of central New Jersey. By 1833, a village of six to eight dwellings clustered where the north-south route of a Lenape ridge trail crossed an east-west route running inland from the Atlantic Ocean. Farmsteads, a church, and a tavern marked this intersection before the American Revolution. The hamlet's name—"Shark River Village" or "Trap"—connoted all the coastal land between Shark River and Squan Town (Manasquan), in what was then Shrewsbury Township, now Monmouth County, New Jersey. The waterpower of nearby Shark ("Shirk," "Shack") River and Jumping Brook invited the building of sawmills and gristmills in the 1800s, increasing the economic pulse of the area and hastening Trap's settlement. The area's first blacksmith and wheelwright (Elhanan Stout, 1803), dry goods store (William Remsen, 1826), physician (Dr. John Lewis, 1840), bootmaker (George Sculthorpe, 1850), and post office (1869) stood at the village crossroads before the century turned again. Prior to the Civil War, Shark River Village became known as "Greenville," then "Hamilton" after the war. On February 26, 1879 it was renamed "Neptune" and became part of the newly chartered township of Neptune, along with Asbury Park, Ocean Grove, Shark River Hills, Avon, Neptune City, and Bradley Beach. As the area developed into a seaside resort economy, Neptune remained primarily a farming community until the 1960s. Newer neighborhoods with names like Whitesville (1870s), West Grove (1880s), The Gables (1920s), Bradley Park (1930s), and Midtown (1940s), grew up around Hamilton. With today's modern highways—Routes 18, 33, 35, 66, and the Garden State Parkway—crisscrossing Neptune, its sobriquet, "Crossroads of the Jersey Shore" is aptly chosen. Nonetheless, Neptune retains much of the American small town tradition with its tree-lined streets and neighborhood schools, and the charm of country roads and old farms can still be found in its western section.

Shark River Hills with its hills and sandy terrain, did not invite farming, but early on it offered bounties of fish and shellfish, boat building opportunities, and the pure heaven of its beaches for recreation. "The Hills" was an economic resource and recreation spot for two centuries before it was developed as a summer resort in the 1920s. Locals fished there, harvested oyster beds, and built boats on the river. Perhaps an ancient shark—lost in legend—was the stream's namesake. Or perhaps the "easy life," passed in the hunting and fishing shanties along its banks, lent the name "Shack" or "Shirk" to the river, which eventually metamorphosed into "Shark" River. Generations of families enjoyed horseback riding, swimming, boating, and clambakes on its beaches. One hundred nineteen species of birds flew amidst its mountain laurel, holly, and dogwoods, with pheasants, rabbits, and deer prospering on the area's wild nuts and huckleberries.

The appeal of this place was not lost on lawyers James Carton and Frank Durand. A county Poor Farm which had operated since 1801 on the 700-plus acre site had shut its doors in 1911. In 1913, Carton, Durand, and a group of lawyer-investors from the Asbury Park area purchased 728 acres, sold off a parcel to Asbury Park for a golf course, and used the proceeds to develop the remainder into a summer resort known as Shark River Hills. In 1923 they hired Morrisey and Walker of Keansburg as real estate agents, and the promotions began. Slogans such as "The New Asbury Park Suburb" were coined. The Shark River Hills bathing girl appeared on signs and in print. Characterizations like "Acres of Diamonds" and "Gold in the Hills" suggested that Captain Kidd's treasure was buried in the development. Roads were cut, lots were laid out, and sales began in 1924, with many lots sold while still under water. Streets went in, and electricity, and water lines. A country club and playground were built, plus a boardwalk, pier, and diving tower. James Carton's vision was on the money, and hundreds of bungalow homes soon dotted the Hills. The 1930s economic Depression crimped Shark River Hills' expansion, but the 1940s and 1950s saw new developers entering the game, building all-season houses, and attracting middle-class buyers. Today, Shark River Hills is a community of year-round dwellers instead of an enclave of summer neighbors, but it maintains its sweeping water vistas and much of the natural beauty which have always recommended the place.

One

THE OLD HOMESTEADS

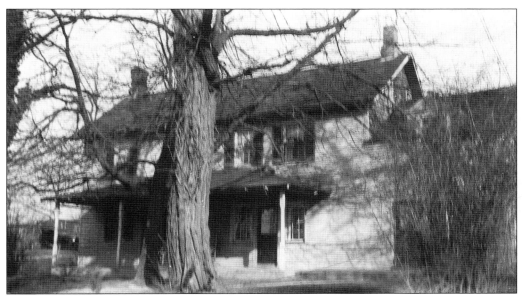

The DeWitt Shafto House is seen here, *c.* 1930. DeWitt Shafto (1823–1892) was the grandson of Anthony Shafto, who came from Yorkshire, England in 1750. DeWitt married Hannah Morris and had two children, Edwin and Augusta. The house dates from 1790 and features distinctive 18th-century construction: hand-hewn ceiling beams, wattle-and-daub walls, and mortise-and-tenon joints. The house still stands at 1017 Old Corlies Avenue. (Neptune Historical Museum.)

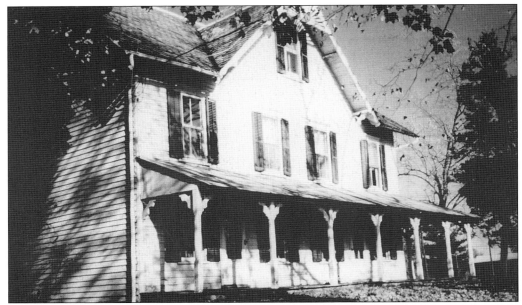

Stout Farm was built by Elhanan W. Stout in 1832 on the old Lenape trail, which became Jumping Brook Road. Elhanan and his brother Samuel lived with their families in either side of the duplex-style house while operating the area's first blacksmith and wheelwright shop nearby. The house was remodeled and expanded in the Victorian era and again in the 1930s, which accounts for its mixed architectural vernacular. It was continuously occupied by six generations of Stouts until 1979, when it passed out of the family to a developer, who razed the landmark farmhouse on October 1, 1998. (Courtesy Addie Van Dyck.)

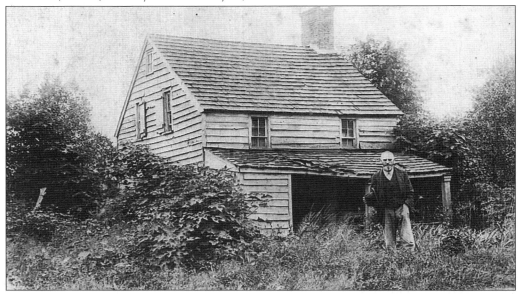

George Franklin Shafto (1853–1914) is shown in front of his mother's house in Hamilton, c. 1880. George's mother was Emily King Shafto (1828–1896) who married George W. Shafto (1817–1894). The house was extant through the first quarter of this century and stood on the property occupied by today's Franklin Estates. (Courtesy Peggy and Bob Burdge.)

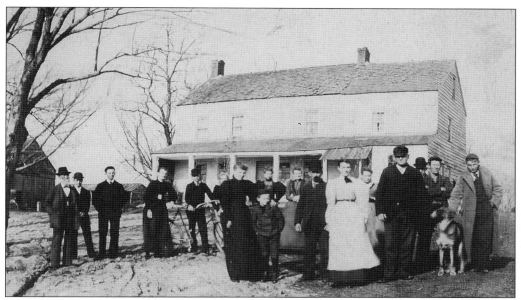

DeWitt Shafto's brother, George Washington Shafto, built his homestead in Hamilton about 1850. This house still stands at 801 Old Corlies Avenue. The only individual identified in the photograph is George Johnston (a relative of the Shaftos), who is seen at right petting the dog. Clothing styles—especially full-puff sleeves on the women's dresses—indicate this photograph was taken in the late 1880s. (Neptune Historical Museum.)

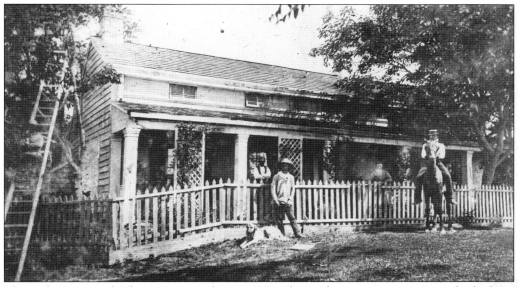

This is the Eastwood White Homestead at 729 Wayside Road, as seen in 1900. It was built about 1850. The house, with its narrow eyebrow windows and bayed porch intact stands today, minus the picket fence, garden gate, and trellises which lent so much charm. Eastwood White was the grandson of Britton M. White, a Tory who lost his lands for supporting the British during the Revolution. Britton returned in 1819 to purchase lands along Deal Lake, and pioneered settlement of western Asbury Park. Eastwood was also the nephew of Bloomfield White, founder of Neptune's Whitesville section. (Neptune Historical Museum.)

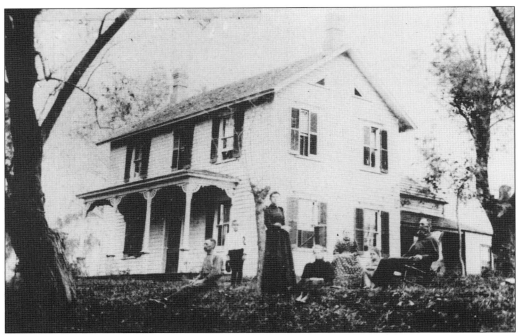

The Simpson house stood just in from the northwest corner of Corlies Avenue and Green Grove Road. The farmstead included 5 acres of property. Enjoying the homestead yard around 1898 are the Simpson family and friends. The farmstead appears on the 1851 Lightfoot map of Monmouth County. (Neptune Historical Museum.)

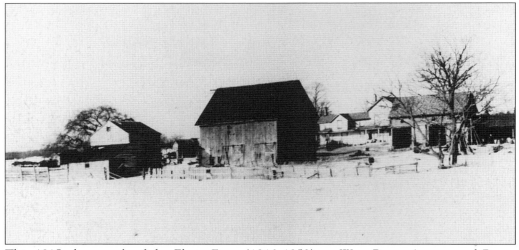

This 1915 photograph of the Elmer Farm (1846–1950), at West Bangs Avenue and Route 33, shows, from left to right, the wagon house, corncrib, storage barn, 11-room farmhouse (background), and wagon shed. The original farm was 52 acres; its produce and raw milk was sold to local dairies. In 1950 it was sold to Bradley Beach's mayor, who resold it as a site for Holy Innocents Church and School. The Elmer Farm often offered work in exchange for a place to stay, and many colorful characters stayed there over the years. Truman Prescott, who scouted for Colonel Custer at the Little Big Horn and rode with Teddy Roosevelt up San Juan Hill, lived ,worked, and died on Elmer's Farm. (Courtesy Peggy and Bob Burdge.)

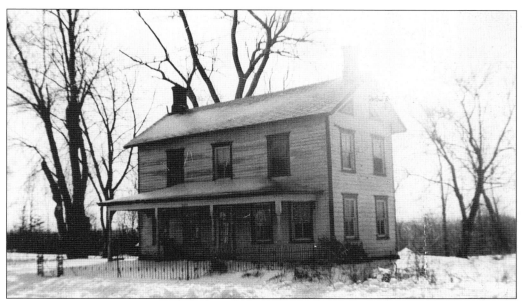

Shown here is the Everett Newman home at 1010 Old Corlies Avenue as it looked in 1946. Built around 1874, the house stood just east of the owner's business, the Newman and Lane Blacksmith shop. (Neptune Historical Museum.)

The Sculthorpe Farm was photographed in 1963 when Commander Ike Schlossbach lived there and operated the Asbury Park Air Terminal on the property. The Sculthorpe family arrived here from England in 1831 and the house was built about 1840 by James Sculthorpe as a homestead for him and his wife, Ann. The house burned in 1977. Today the site is home to the US Life Building, at Jumping Brook Road and Route 66. (Neptune Historical Museum.)

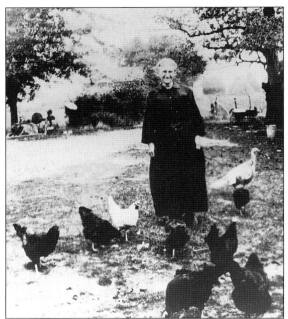

Mrs. Hannah White Sculthorpe, photographed about 1910, exudes a quiet contentment with life upon her Neptune farm. She is surrounded by feathered friends, consisting of black and white chickens and a turkey hen. The tree seen in the background at left still grows near the US Life Building, which was built on the farm site. (Courtesy Elsie Morrison.)

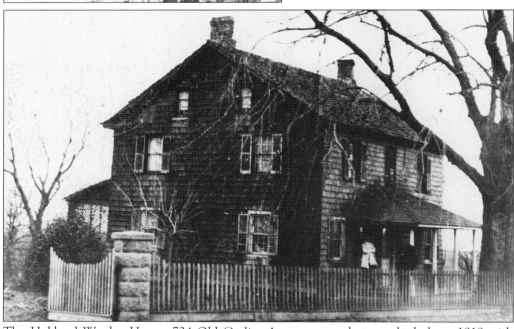

The Hubbard Wooley House, 724 Old Corlies Avenue, was photographed about 1919 with then-owners John Everson, a commercial fisherman, and his wife, Anna. Hubbard Wooley and wife Nancy built this homestead sometime after December 7, 1840, when John Wooley "of Long Branch" (relationship unknown) conveyed the land to them. The property is described as land on the north side of Shark River, "beginning at the north edge of the old road [Old Corlies Avenue] leading from Richard Davison's Tavern [seen on 1851 Lightfoot Map] to the County House" [now Shark River Golf Course]. An enlarged version of the house still stands. (Neptune Historical Museum.)

The Holly Brook Pub and Restaurant, 3409 West Bangs Avenue, dates from the 1830s. In the late 1800s it was owned by Nathan J. Taylor. In the early 1900s it was owned by Frank Jackson. Both men operated it as a dairy farm. The property became a truck farm beginning in 1905 and in the 1920s boarded inner-city children, who helped with the farm work. The building later served as a grocery, a restaurant, and a bar known as the Coach House. (Personal photo.)

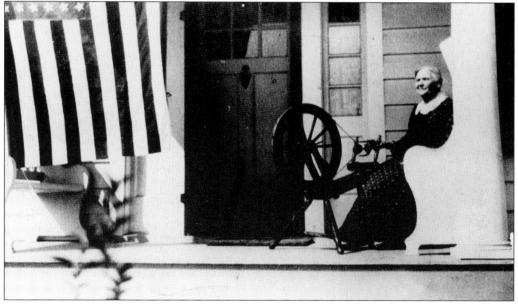

Amanda Sculthorpe Van Brunt (1843–1928), wife of W. George Van Brunt, seems as much an icon of Americana as the flaxwheel and American flag on the stoop of her Van Brunt homestead, seen here about 1925. The homestead stood where Remsen's Mill Road comes into Old Corlies Avenue. Mrs. Van Brunt's austere attire during the height of 1920s flapper fashion reflects the simple style of her Quaker faith. (Courtesy Dolores Murray.)

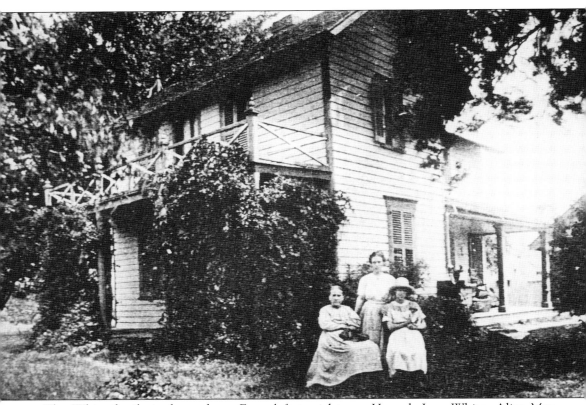

The White family is shown here. From left to right are: Hannah Jane White, Alice May White Furman, and Thelma Furman. The family posed around 1900 in their Whitesville yard. Whitesville was named for Hannah's husband, Bloomfield White, who settled the northeast section of Neptune. Their farmstead, dotted with willow trees and watered by the area's many springs, was called Willow Brook Farm. After Mr. White's death in 1886, "old Jane White" sold off bits of the farm and raised white potatoes, sweet potatoes, corn, and eggs to keep the family going. The homestead was razed in 1961. The street name "Bloomfield Avenue" and the neighborhood name of "Whitesville" remain to document the Whites' presence here. (Neptune Historical Museum.)

Two

NATIVE AMERICAN CONNECTIONS

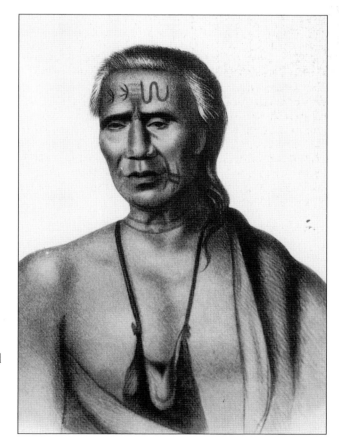

Lenape Chief Lappawinsoe had his image painted in 1735. Beginning over 10,000 years ago, New Jersey's indigenous Lenape people (called Delawares by the English) enjoyed life in the Neptune area, where freshwater springs, plentiful game, and rich fishing grounds invited year-round campsites. Many Lenape artifacts have been found locally, and a Lenape gravesite was discovered in the area of Shark River Park. (Painting by Gustavus Hesslius.)

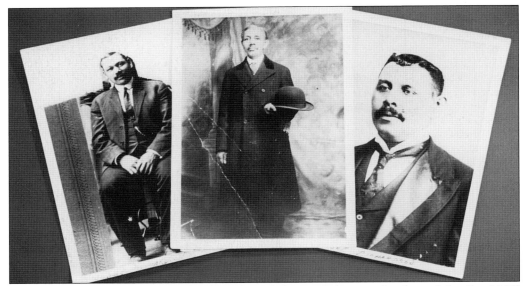

Theodore, Isaac, and Joseph Richardson (seen left to right), were the first of the Sand Hill Band (Cherokee/Lenape/African American) to settle in Neptune. Some of the Sand Hill Band relocated from Reeveytown (near Eatontown, New Jersey) about 1877 and worked as farmers, laborers, butchers, and carpenters. They were responsible for constructing many buildings in just-developing Asbury Park and were paid in land owned by its developer, James Bradley. Choosing 15 acres on Springwood Avenue in Neptune (instead of beachfront property which became Convention Hall), the Richardsons settled the hilly area on West Lake Avenue which would become known as Richardson Heights. (Neptune Historical Museum.)

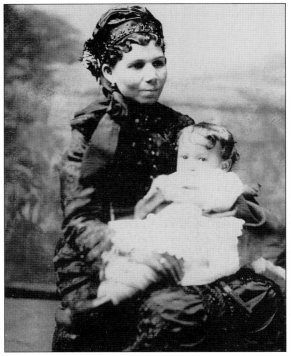

Sand Hill tribe-member Elizabeth Richardson Vanderveer, born in 1850, married wealthy Dutchman Theodore Vanderveer and moved to New York City, where she lived with her husband and three children. Here, baby Luxie rests sweetly on Mama "Libby's" lap. (Neptune Historical Museum.)

Christina Dickerson (right), born in 1892 in Richardson Heights, was a lifelong Neptune resident until her death in 1979. Seen here in traditional dress, Christina wore standard street clothes for everyday attire and native regalia for tribal get-togethers. Mrs. Dickerson was a choir member and organist for Saint Augustine's Episcopal Church in Asbury Park, and taught piano locally. (Neptune Historical Museum.)

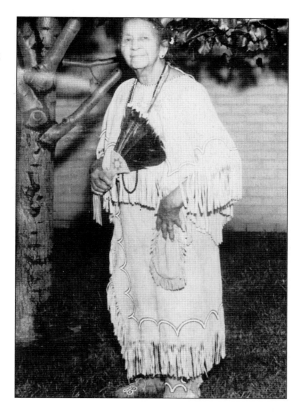

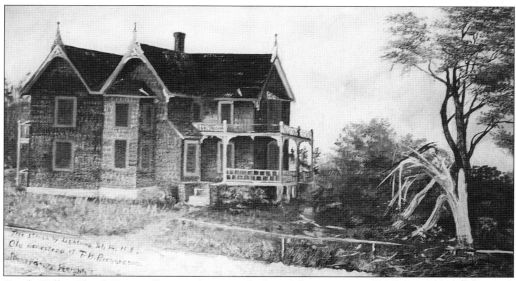

Sand Hills Chief Ryers Crummel painted this oil painting of Theodore Richardson's house at Richardson Heights after lightning split a nearby tree on July 14, 1912. (Neptune Historical Museum.)

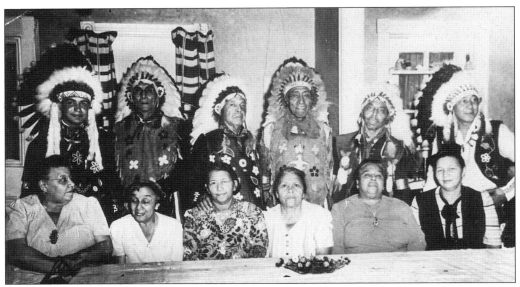

The last resident generation of the "Sand Hill" band enjoys a 1948 family reunion in Neptune. At yearly gatherings—held at Long Point or at 2113 Springwood Avenue—tribal attire replaced street clothes. (The Sand Hill men wear Eastern Woodlands Indian clothing except for their large feather headdresses. These Sioux war bonnets were adopted by Native Americans everywhere once wild west shows and movies suggested these were what "real" Indians wore.) The last pow wow in Neptune was held in 1949. From left to right are: (seated) Theodora Bell, Edith Gardner, Christina Dickerson, Adeline Thomas, Restella Fox, and Charlotte (Gaines) Holman; (standing) James Revey, Jonathon Richardson, Isaac Richardson, Chief Ryers Crummell, Robert Richardson, and Robert Revey. (Neptune Historical Museum.)

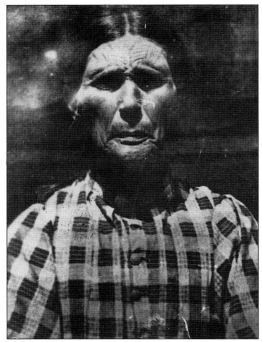

Elizabeth Harker Elmer (1832–1915) married James Henry Elmer (1829–1903) on November 6, 1853. Mrs. Elmer was one-half Native American and was known as a local medicine woman whose healing skills with medicinal plants benefited family and neighbors. Elizabeth worked on their family farm (now site of Holy Innocents School and Church) and raised a family of 11 children. This photograph of Elizabeth was taken around 1870, when she would have been around 40 years old. (Courtesy Peggy and Bob Burdge.)

"Chief" Claude Newberry, Native American, captained the Neptune team during his high school years there, and returned to coach winning football teams for Neptune High School for some 20 years between 1910 and 1930, including the undefeated 1923 State Champion Football Team. (Neptune Historical Museum.)

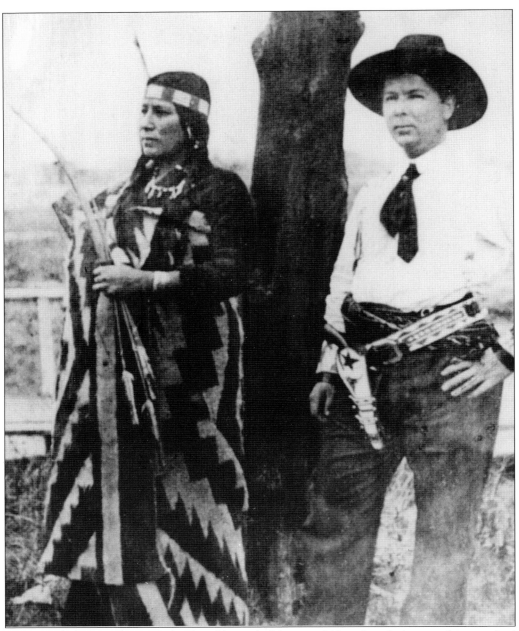

Joe Lopez (Chippewa/Aztec Indian) and his wife, Margaret (Abenaki tribe), were photographed in 1904. Joe came to Neptune from Sante Fe via Buffalo Bill Cody's Wild West Show, where he performed with Annie Oakley and Buffalo Bill himself. In 1904 he married Margaret, an expert basketmaker, and they settled in Neptune where he distinguished himself as a mural artist and scenic designer for the legendary Steeplechase and Asbury Park Baby Parade floats. The family name continues in Neptune with grandson Joe Lopez of Francioni, Taylor and Lopez Funeral Home. (Neptune Historical Museum.)

Three

TRADESMEN AND BUSINESSES

In the 1840s E.R. Height (Haight) ran a stagecoach line between Manasquan and Oceanport, running through old Neptune via Jumping Brook Road. Height transported U.S. mail as well as passengers in his four-horse coaches, which held eight persons. Stops en route were Manasquan, New Bedford (Wall), Shark River Village, Wayside and Eatontown, before arriving at Oceanport where a boat connection to New York City awaited. The fare one way was 87 1/2¢ (Neptune Historical Museum.)

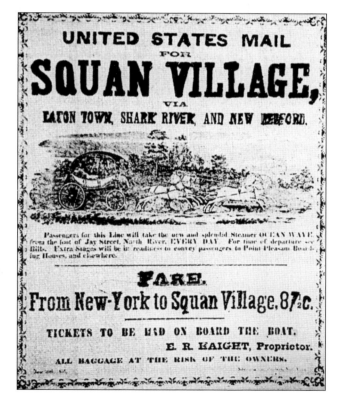

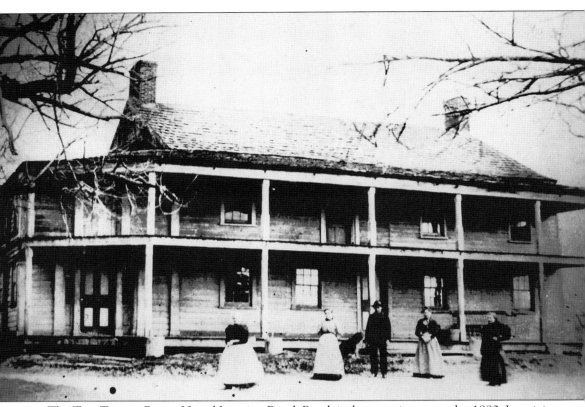

The Trap Tavern, Route 33 and Jumping Brook Road, is shown as it appeared *c.* 1880. Its origins obscured by time, this tavern's name defined the area when all the land from Shark River to the Manasquan River was known as "Trap." Legend says the owner's wife over-supplied applejack brandy to an otherwise sober traveler. Recovering days later he swore he'd never get caught in "that trap" again, hence the name. Another legend attributes the name, "Trap," to an incident during the Revolutionary War where British sympathizers were "trapped" and held captive at the tavern. There is no documentable proof of either explanation for the Trap name, but if there was a confrontation with the British it was unlikely it occurred in the tavern above, which was opened (according to the earliest available tavern license for the site) in 1803. It is possible such an incident took place at an earlier tavern north of this one on Jumping Brook Road, called "The Mudfort." Buttons bearing the British crown were found there. Once defunct, its colorful legend and "Trap" name may have been misapplied to the newer tavern above, which originally stood where Redeemer Lutheran Church stands today. Taverns served as the social centers of farming locales, hosting community gatherings from newspaper readings to court sessions. Trap Tavern, with its strategic location along Height's stage route was a regular stage stop. It was also a rest stop for the mule-drawn carts carrying iron pipe from Allaire Works to Oceanport. The tavern was moved 150 feet eastwards in 1930 to make way for Route 33. It became derelict and was razed in 1946. (Neptune Historical Museum.)

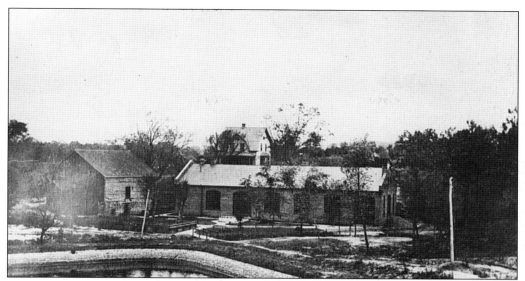

Bowman Kisner's Mill, standing to the left of the Monmouth Consolidated Water Company and its settling basin on Old Corlies Avenue, was photographed in 1902. Kisner's was a gristmill, built about 1825 as a forge which utilized the waterpower of Jumping Brook. Garrabrant's sawmill and Frenchman's Mill stood upstream on Jumping Brook. Shafto's sawmill, plus a sawmill and a gristmill (on either side of Schoolhouse Road) employed the Shark River's power, with Remsen's Mill below it on the Shark River's headwaters. Active until the 1890s, Kisner's was the last area mill to cease operations. The building is now gone, as is the Van Brunt farm on which it stood. (Neptune Historical Museum.)

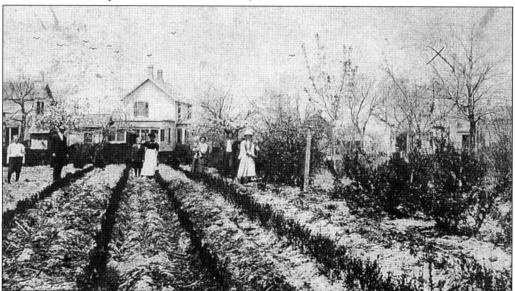

O'Hagan's Nursery has been in business on Cortlandt Avenue since 1896, when it was founded by William O'Hagan. Five generations later, June O'Hagan Applegate and family continue in the business of growing shade trees, hollies, and ornamental shrubs on the 11-acre property. This 1911 postcard signed by Florence O'Hagan notes: "These are our houses." They still stand, along with a barn, just out of view of motorists on Route 35. (Courtesy Helen Pike.)

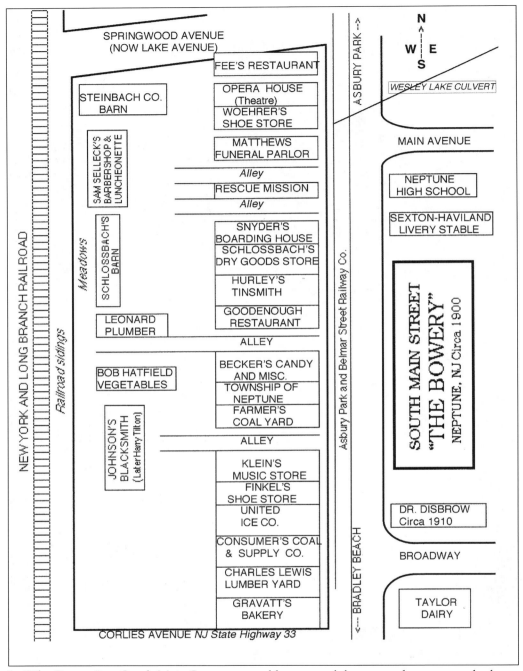

In "The Bowery" on South Main Street you could get a meal, buy some shoes, or see the latest "entertainment." Fires and demolition claimed this business center over the years, leaving only a large vacant lot in its place. (Reformatted from *Ike's Travels*, by Peggy Goodrich.)

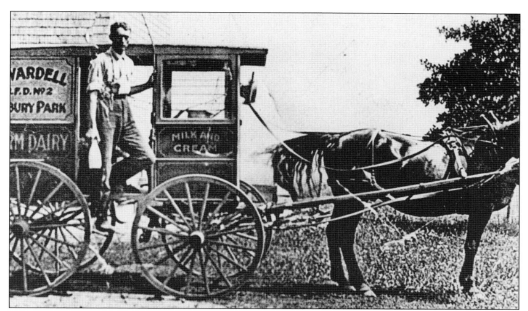

Albert "Pop" Wardell, founder of Wardell's Dairy, on Old Corlies Avenue, is shown with his delivery wagon about 1914. Many local processing plants—Sutts, Taylor, Wooley, Tilton, and Sickles and Wardells—processed raw milk purchased from Neptune farms, then delivered their dairy products to the greater Asbury Park area. The firms closed down as milk suppliers moved out of the area. On January 1, 1975, Wardell's was bought out by Welsh Farms, which occupies the site of the former Wardell Dairy on Old Corlies Avenue. (Neptune Historical Museum.)

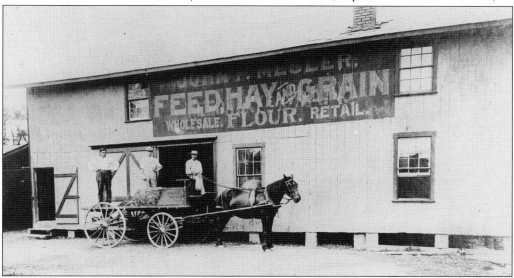

The John F. Mesler Feed, Hay, and Grain Company, at Corlies and Railroad Avenues, was photographed in 1905. Then still largely featuring an agricultural economy, the larger Neptune area relied heavily on businesses like Mesler's to feed farm animals, which represented a hefty investment. Even 20 years later life hereabouts was hardly citified. In 1920 Neptune had to pass a law to control the number of goats roaming its township streets. (Neptune Historical Museum.)

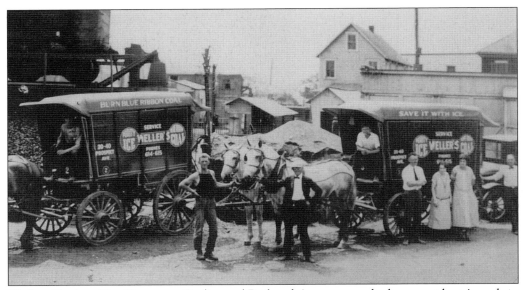

Wellers Coal and Ice Company, Corlies and Railroad Avenue, supplied area residents' needs in winter and summer. Employees posed with trucks, delivery horses, and equipment at the railroad siding in Neptune about 1925. Wellers came from Trenton about 1916, establishing both this business and the United Ice Company on Main Street, which made the first manufactured ice in this area. (Courtesy Bill Lachenauer.)

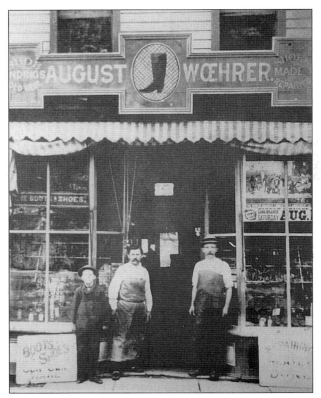

Cobblers stand in the doorway of August Woehrer's shoemaker shop about 1890. Busy South Main Street was known as a local center for the manufacture of shoes and boots. Folks were probably looking forward to the traveling circus, advertised in the store window poster, coming to fashionable Long Branch that summer. (Neptune Historical Museum.)

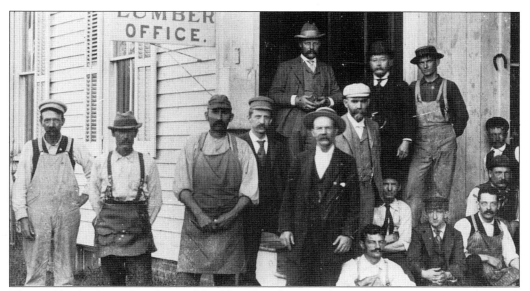

This is Charles Lewis Lumber and Building Supplies, 123 Main Street, as seen in c. 1880. A spectacular fire destroyed the main building, sheds, and part of the lumber yard on March 1, 1934. Students at Neptune High across the street were dismissed due to the intense heat and smoke. Mr. Lewis constructed a larger building of brick and re-opened within the year, remaining in business on the same site until a fire in March 1970 finally closed Lewis Lumber. (Neptune Historical Museum.)

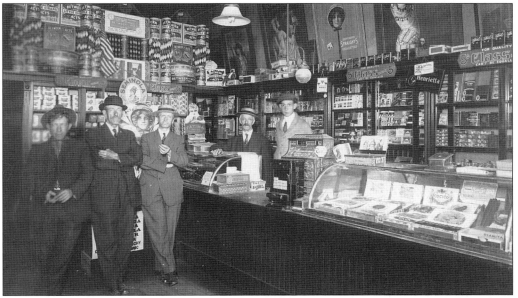

In 1910, rules at Wellington Pharo's Tobacco Store, 139 South Main Street, were most explicit: NO WOMEN ALLOWED. In addition to holding the local line against feminism, Mr. Pharo served Neptune Township as commissioner of Sewer District No. 1. Second from left is Joseph Peterson, followed at his right by Arthur Pharo and Wellington Pharo (Art's son and proprietor). Clerk Claude Lawlor stands behind the counter with an unidentified young helper. (Neptune Historical Museum.)

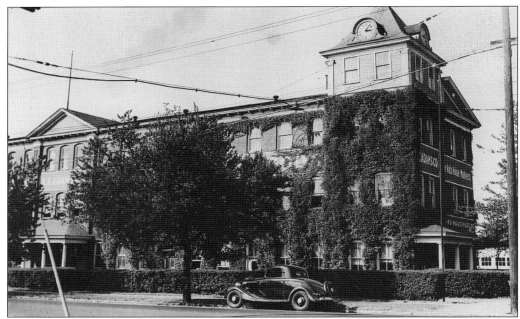

The S.S. Adams Company, at the corner of Memorial Drive and Seventh Avenue, in Neptune, has been turning out gag items at this location since 1932, when it bought the building. Sorenson S. Adams, the founder, invented the dribble glass, the whoopee cushion, itching powder, and many more jokester classics, rising above the competition to become America's only manufacturer of such novelties. The factory was built in 1893 by the Symphonium Music Company, which manufactured large perforated metal discs that played tunes on a juke-box like machine. The building's familiar clock tower still offers the time to hurrying passersby, but is minus its flagpole, which was lost in a storm. (Courtesy Chris Adams.)

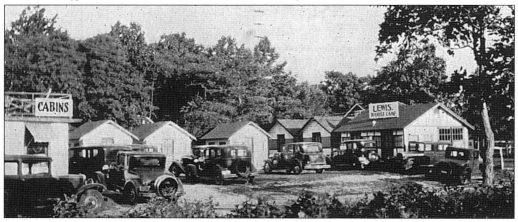

Vacationers are shown at the Lewis Tourist Camp, 1501 Corlies Avenue, in 1935. Cabins or tents could be had for a fee at this then-countrified location where Route 35 meets Route 33. New owner James Eldridge changed its name to Eldridge's Cottage Camp in the 1940s, and added to its notoriety by keeping a 6-foot pet alligator there. Despite its luxurious home in a bathtub, the animal was renowned for taking unsupervised walks and requiring recapture. The trailer camp—minus the reptile—still occupies an off-the-highway location at the same crossroads. (Courtesy Dick Napoliton.)

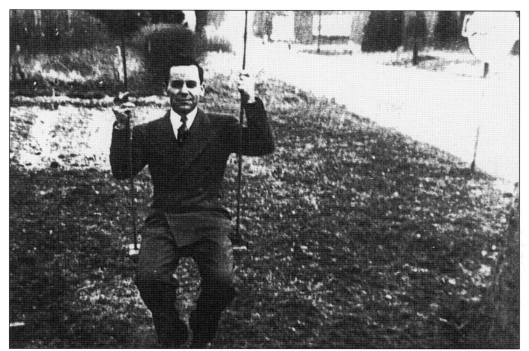

A friend of the Silva family, operators of Shore Orchid Growers, 2419 Corlies Avenue, poses on a rope swing in 1947. August Silva was general manager and grower for this Neptune branch of New York's "Fight Floral Company" from the 1930s through the 1960s. Formerly the Haight family farm, Shore Orchid Growers (now Variety Growers) now grows houseplants, while Silva Orchids (Wayside Road) has, since 1957, produced world-class orchids in its Neptune greenhouses. In the distance are the signs marking the turnoff to Shark River Hills. (Courtesy Connie Hand.)

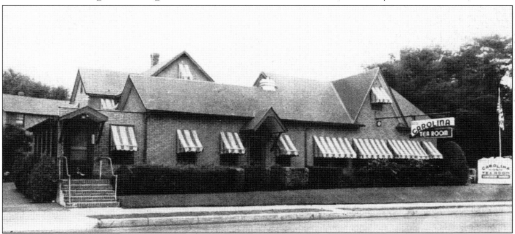

The Carolina Tea Room (1913–1960s), 1734 Asbury Avenue, was run by Mrs. Julia White and Helen Flick. Many people still recall the tasty menus offered by the Tea Room, but few know it began as a private home, built by Tucker Sculthorpe and wife Annie Harker Sculthorpe, after they moved off their Neptune family farm. Neptune restaurants like the Carolina Tea Room, Virginia Tea Room, Mort's Port, and Peterson's were favorite stopping-off places for day-trippers before they headed home after a day at the shore. (Neptune Historical Museum.)

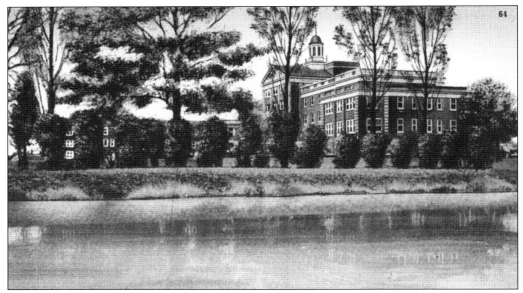

The Raleigh Fitkin-Paul Morgan Memorial Hospital—now Jersey Shore Medical Center—began in Spring Lake as the Ann May Memorial Hospital back in 1905. "Fitkin" opened its Corlies Avenue operation in Neptune in 1932, expanding in scope and size over the years to achieve its current status as Area Trauma Center for Monmouth County. This postcard view shows the hospital with Harkie's Pond to its east. The pond area is now the location of senior citizen housing. Harkie's was a favorite spot for ice skating and supplied ice for Shafto's Dairy at Corlies and Ridge Avenue. (Neptune Historical Museum.)

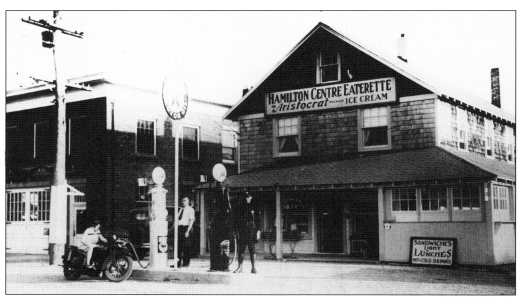

Hiram Jeliff, owner/operator of the Hamilton Centre Eaterette, fuels up Officer Max Pollack's motorcycle while Jeliff's daughter tries the bike on for size, about 1930. The Jeliff family lived above the Eaterette, which was primarily a grocery store but also featured a small luncheonette and offered Texaco gasoline to drivers along Route 33. (Neptune Historical Museum.)

Four

EARLY CHURCHES
AND CEMETERIES

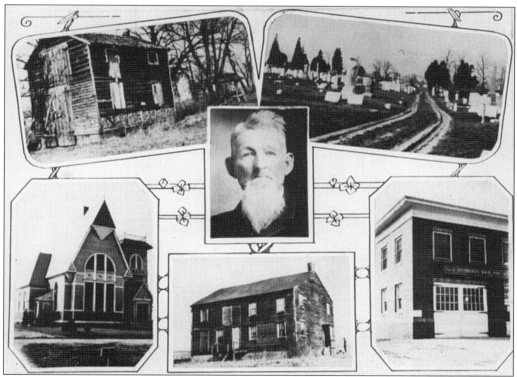

Mr. A. Havens Morris gazes out from the center of this photographic composite of the Hamilton area. Mr. Morris (1828–1913) was a farmer, lawyer, historian, and preacher at Hamilton Methodist Church. Seen (upper left corner) is Hamilton's icehouse, (upper right) Hamilton Methodist Cemetery, (lower left) old Hamilton Methodist Church, (bottom middle) Trap Tavern, and (lower right) Hamilton Fire Company. (Neptune Historical Museum.)

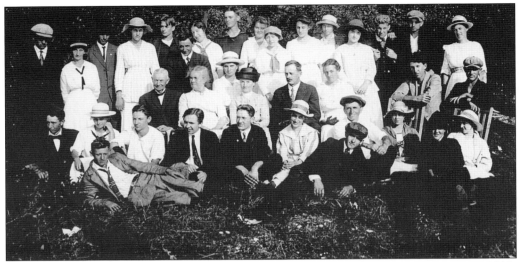

The Young Peoples Society of Hamilton Methodist Church relaxes at an outing in 1912. Participants included: Richard Stout, Florence Stout, Ernest Smith, DeWitt Shafto, Norman White, Eva Martin, Norman Pete White, Anna Whitlock, "Faby," Reverend Van Hise, Mrs. Van Hise, Irene Tilton, Archie Height, Kate Height, Ben Sculthorpe, Naomi Smith, Gladys Cogovon, Bill White, Florence Wright Wooley, Louise Potter, Monroe Newman, and Ted White. (Courtesy Elsie Morrison.)

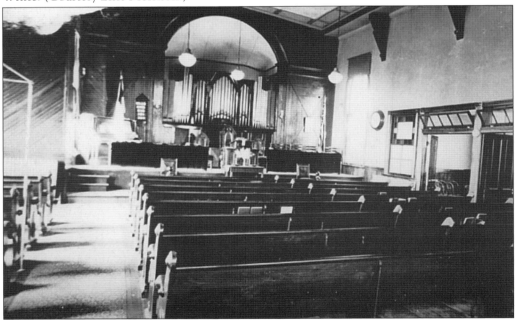

This is the interior of the second Hamilton Methodist Church, as seen c. 1930. Completed in 1888, this "new" Hamilton Methodist Church replaced an earlier church building known as Youman's Chapel, which had been built in 1833 by sawmill owner Jonathon Youmans. Land was donated by Asher Howland and Garret White. Building timber was donated by John Ely. The church name was changed to Shark River Methodist Church, then Greenwood Methodist Church, before becoming the Hamilton Methodist Church in 1875. (Courtesy John Everson.)

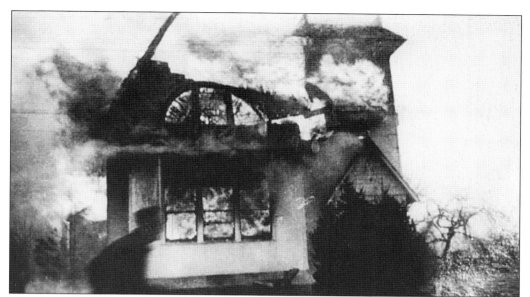

Hamilton Methodist Church is engulfed in flames on November 6, 1940. Destruction of the building was complete, and church records were also destroyed. A new brick church was built on a site across the road and has celebrated services there since October 12, 1940. (Courtesy John Everson.)

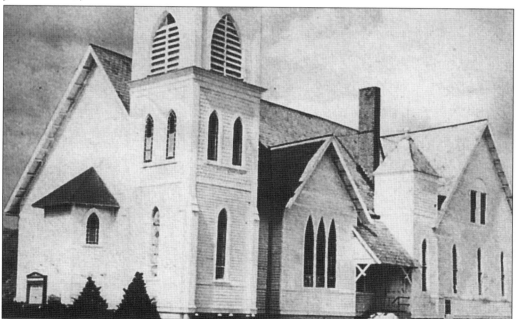

In 1882, West Grove's Methodist parishioners split from St. Paul's Church in Ocean Grove. The new congregation built a chapel with Reverend Cobb, the preacher, walking to and from Long Branch to conduct services. It was soon overwhelmed by worshippers, necessitating construction in 1891 of this church at Corlies and Atkins Avenue. The church bell sounded for both religious services and fires, alerting the Unexcelled Fire Company to action. (Courtesy Dr. Walt Jesuncosky III.)

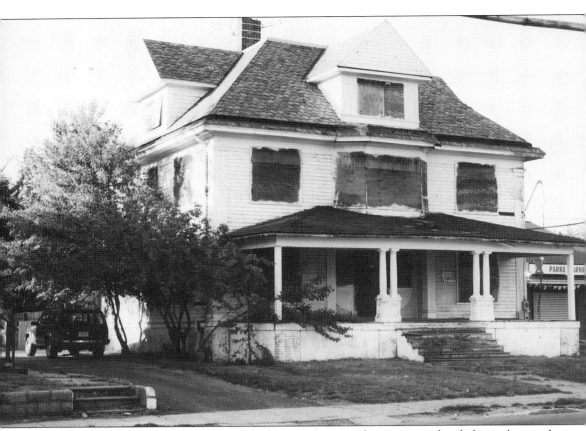

In 1955, with the widening of Corlies Avenue looming large, it was decided to relocate the Westgrove United Methodist Church and parsonage to Corlies and Walnut Street. In 1971, a fire started by an arsonist destroyed a large portion of the old church and all of its records. The West Grove property was sold in 1975, with only the old parsonage (above) left next to a corner pharmacy that occupies the former church site. (Personal photo.)

Shown here is the Old Presbyterian Churchyard, at the southwest corner of Gully Road and Old Corlies Avenue in Hamilton, as seen after a 1964 clean-up project. From 1734 to 1803, a church, a church rectory, and burying ground occupied this site. It was the first church to serve the Neptune area. Most likely affiliated with the Presbyterian Church of Shrewsbury, ministers traveled a circuit, preaching to satellite congregations such as the one that attended this church. All but forgotten, the little cemetery and its stones are all that remain, and are barely visible beneath the tangle of brush which today overwhelms the site. (Neptune Historical Museum.)

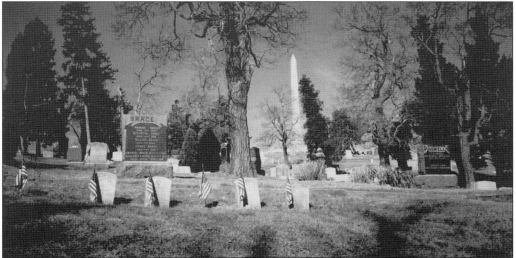

A growing need by seaside communities for a large-scale burying ground prompted the founding of Mount Prospect Cemetery by Willisford Dey in 1881. Rising 100 feet above sea level on a sand dune formed by a primeval ocean, the cemetery's 35 acres are laced with serpentine roads and paths. Mount Prospect's signature piece—the 75-foot Bennett Monument—dominates the hilltop, marking Henry Bennett's success in life as owner of the Bijou Theatre Chain. Sand Hill tribe members, black Civil War veterans, and other luminaries rest together at Mount Prospect Cemetery. (Courtesy David C. Jacobs.)

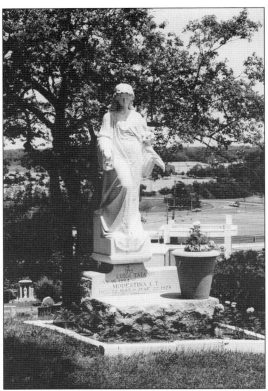

A classical beauty offers grace over a hilltop in Mount Calvary Cemetery. At the turn of the century, burgeoning shore towns were experiencing a population boom, with a natural boost in mortality rates. Mount Calvary Cemetery, on a hill above today's Route 66, was one of the private interment grounds which appeared in the 1890s. (Personal photo.)

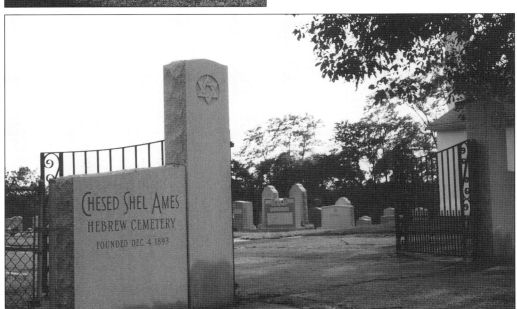

Chesed Shel Ames' Cemetery was established in 1893, making this the earliest of Neptune's Hebrew cemeteries. Adjacent West Bangs cemetery, Congregation Agaduth Akim, and Route 33's Cemetery Beth El are other turn-of-the-century Hebrew burial grounds in Neptune. (Personal photo.)

Five

YESTERDAY'S SCHOOLS

Hannah Benard Stout was the first woman to become a full-time school teacher in Neptune. She came to the old Hamilton School No. 8 in 1877 after teaching in Blandingsburgh (today's Sea Girt), following her graduation from the Young Women's Seminary in Freehold. She replaced the retired local boat pilot who had lasted as Hamilton schoolmaster for just one year. Miss Benard taught at Hamilton for three years before marrying local farmer John H. Stout. Retiring briefly, Hannah Benard Stout returned to teaching at the old Summerfield School in 1895, and retired again in 1916. Hannah's three sisters also became teachers in Neptune. (Neptune Historical Museum.)

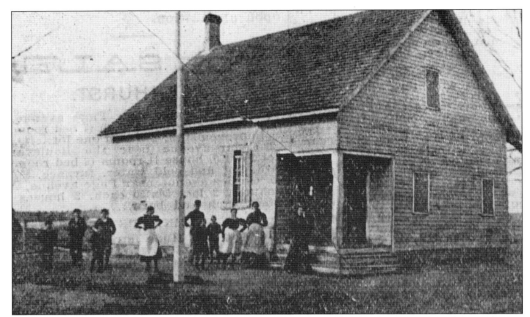

Hamilton School No. 7, pictured about 1898, was the second school to stand at the northwest corner of Schoolhouse Road. It replaced Neptune's very first school—also a one-room frame building—built around 1800 on this land donated by John Ely "for school purposes." In 1885 Hamilton School boasted 117 school-aged children, but a shift of population away from the school saw attendance dwindle and the school closed forever on September 20, 1911. The old school building stood until the 1930s. (Neptune Historical Museum.)

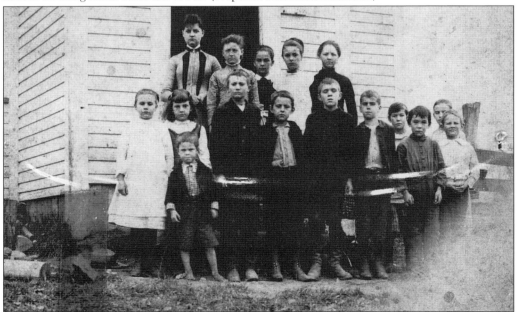

A barefoot boy posed with classmates and teacher in 1885 at the second Whitesville School. Built about 1840, this frame schoolhouse replaced the old log school constructed there about 1828. (Neptune Historical Museum.)

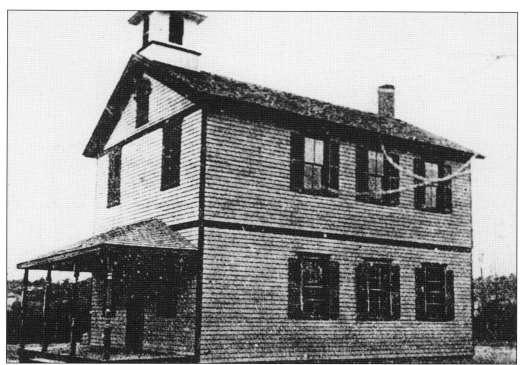

In 1890, a two-story Whitesville school replaced the 1840 building. It featured a 6-foot fence to protect pupils from wildlife in Logantown's woods. Children from Shark River to the Asbury Park line walked to classes there, and saw the area's name change to Whitesville about 1875. In 1914 this schoolhouse was moved to 107 Anelve Avenue, Neptune, where it remains as a private residence. (Neptune Historical Museum.)

Asbury Park was part of Neptune Township from 1879 to 1897, with the two towns sharing educational facilities. The first floor of Park Hall (Main and Cookman Avenues, Asbury Park) was used as classroom space for 60 Asbury and Ocean Grove pupils. Miss M. Crowell, niece of Asbury Park founder James Bradley, was teacher there. In 1874, under its new designation as Asbury Park and Ocean Grove District 90 1/2, Park Hall's responsibilities expanded to include West Grove, West Park, and Bradley Beach students. (Neptune Historical Museum.)

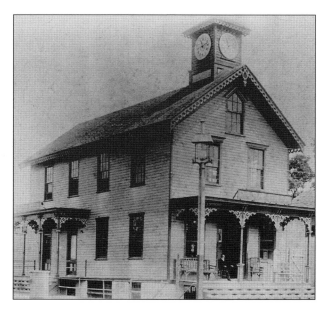

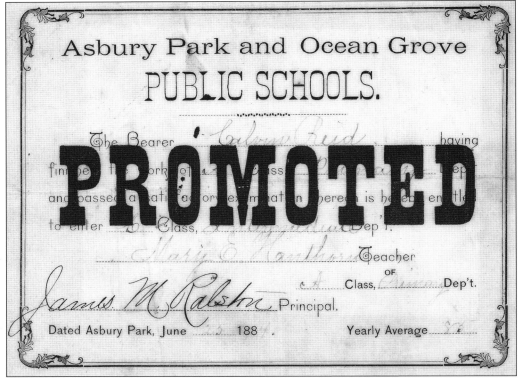

Asbury Park and Ocean Grove
PUBLIC SCHOOLS.

The Bearer _____ having fin___ ___ work of ___ Class _____ Dep't and passed a satisfactory examination herein is hereby entitled to enter ___ Class, _____ Dep't.

PROMOTED

_____ Teacher OF _____ Class, _____ Dep't.

James M. Ralston Principal.

Dated Asbury Park, June ___ 188_ . Yearly Average _____

Formal certificates of promotion documented each passage from grade to grade in a student's school career. Achieving promotion and receiving the accompanying certificate might represent the pinnacle of a pupil's education, rather than a high school graduation diploma. Finishing high school was far from the encouraged expectation we see nowadays. (Neptune Historical Museum.)

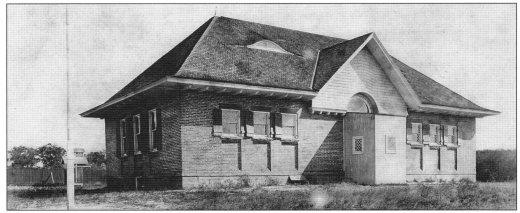

Summerfield School No. 7 is shown here, *c.* 1900. The shift of population which closed Hamilton School No. 8 created the need for a school in the Summerfield area. Summerfield School No. 7 was built around 1897, on the corner of Green Grove Road and West Bangs Avenue. Teachers there were Hannah Benard Stout and Mary L. Kauffman. The building closed as a school in 1929, then was purchased in 1940 by the Neptune Sportsmens' Club. It currently functions as a private pre-school. (Neptune Historical Museum.)

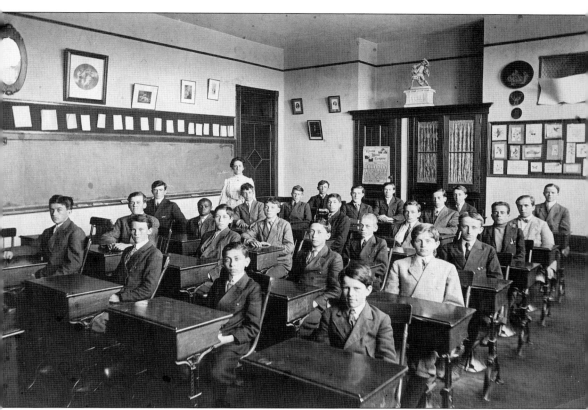

School will always be in session in this 1911 photograph taken of Neptune High School's male students, grades eight through 12. The teacher is Alice Benard, sister of Hannah Benard Stout, who also taught in Neptune. Handwritten notes taken from the photgraph's reverse side provide partial identification for pupils in the photo. The following names are listed as row members (seated front to back) beginning with row on far right: George Perry, Vernon Leaw, Leonard Broom, Vernon Jackson, and Norwood Lindell; (second row) Samuel Side, Ben Goldstein, Arthur Savitz, Oliver Britton, Blanchard Noe, and Merton Sweeney; (third row) Fred Hurley, Jim Forsythe, George Johnson, Frank Sutton, Adolphus Day, and Walter Hagerman; (fourth row) George Smith, Ed Thompson, Carl Low, and Paul Morgan. (Neptune Historical Museum.)

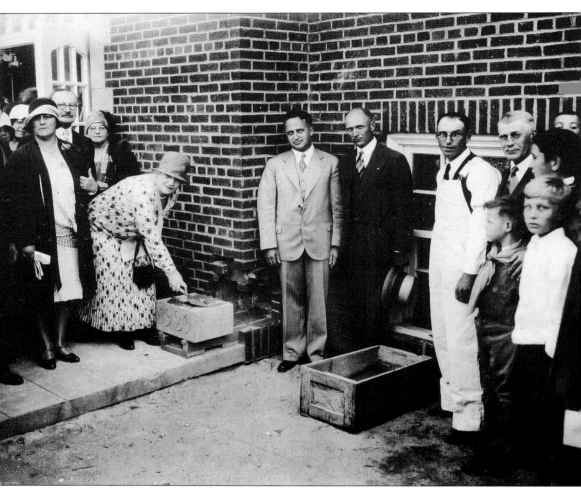

Setting the 1929 cornerstone for Summerfield School No. 4, from left to right are: Board of Education members Gus Knight, Mrs. Janet Bouse, Mrs. Hattie English, and John F. Knox; Board President Mrs. Mary Stout (with trowel), Supervising Principal O.J. Moulton, Board of Education Vice-President John B. Stout, Construction Foreman Johnson (with mustache), Boy Scout John Everson, and Robert White (white shirt). The cost of this new school on Green Grove Road was $192,087, which included a fish pond in the kindergarten room. (Neptune Historical Museum.)

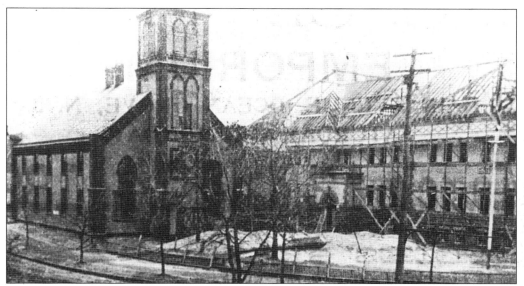

Saint Paul's Church is shown here after its purchase by the Board of Trustees for use as a school. This church at Main Street and Lawrence Avenue was bought for $8,000. Another $4,000 was spent remodeling the building into eight classrooms. Mr. James Ralston was its first principal, with Miss Lida Doren his assistant. Construction on the new Neptune High School had already commenced adjacent to the church, as seen in this photograph about 1896. Saint Paul's served as a school until 1898, when the new high school opened. (Neptune Historical Museum.)

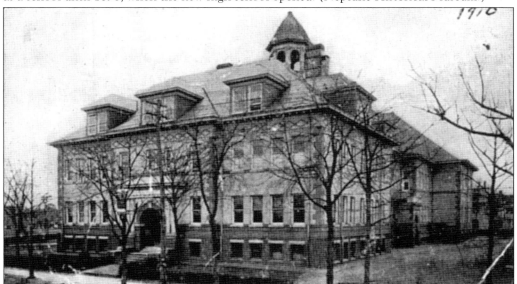

Old Neptune High School, South Main Street, is shown here in 1910. Completed in 1898, Neptune Township's new high school was a jewel. Architecturally majestic, its tastefully appointed interior featured beautiful matched hardwoods, a brass chandelier, and a grand staircase. It initially boasted 16 rooms plus a 1,000-seat auditorium, with two basement classrooms added in 1903 to ease overcrowding. The building took honors for its architectural excellence when it opened. The central tower was removed later for fire safety considerations. (Neptune Historical Museum.)

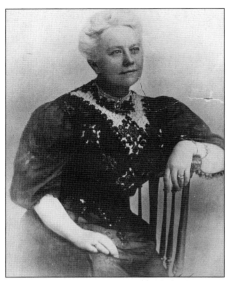

Miss Lida A. Doren was New Jersey's first female school principal and its first woman school superintendent. In 1887, Miss Doren was assistant principal at Saint Paul's church/school. When Neptune High School opened in 1898, she became its principal. She also served Township Schools as supervising principal (superintendent of schools) overseeing eight schools and over 2,000 pupils until her death in 1917. Miss Doren was an avid promoter of high school sports and is remembered fondly both for her great school spirit and for the annual venison dinners she hosted for all the school's athletic teams. (Neptune Historical Museum.)

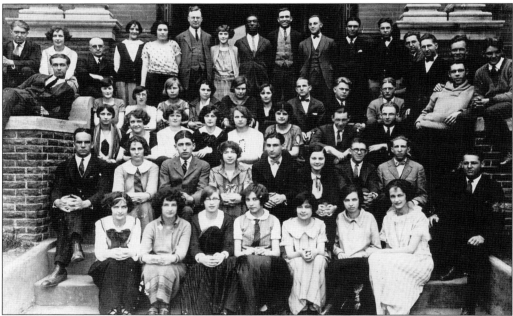

This is the Neptune High School Graduating Class of 1924. Pictured from left to right are: (top row) Douglas Blair, Margaret Phillips, Paul Eckert, Mary Pratti, Lillian Michelson, Dusty Rhodes, Viola Burdge, Arnold Brown, Eugene Capibianco, Chas Jaques, Walt Quinn, Forrest Holmes, Robert Tonpkins, Fred Jacobus, John Van Nortwick, and Jimmie Laird; (second row) Byron Holmes, Yetta Sininsky, Frederica Quelch, Eleanor Reimer, Jean Gillan, Dorothy Baer, Ada Reid, Ross Beck, Bill Wooley, Eddie Larson, and Joseph Patterson; (third row) Ruth Mason, Johanna Luttman, Ruth Vail, Ruth Brand, Muriel Gregary, Harriet Hulsart, Jim Clancy, Auten Reid, and Joe Paterson; (fourth row) Bush Wilson, Flo Kennedy, Fred Fischer, Ruth White, Henry Tusting, Helen Shubert, Eugene Shafto, and Chas Conover; (fifth row) Mabel Murray, Vivien Estelle, Ingeborg Grunke, Helen Harvey, Alice Polhemus, Gertrude Rossborough, Edith Wright, and Teddy Schlossbach. (Neptune Historical Museum.)

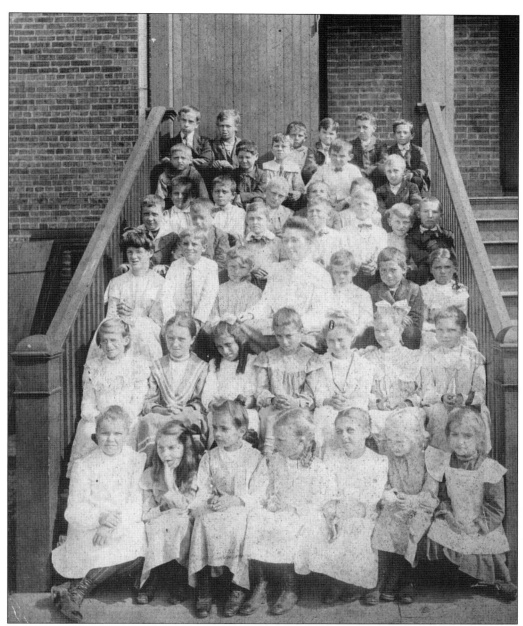

Teacher Miss Bartine posed in the midst of her Bradley Park third grade class in 1914. Pictured from left to right are: (first row) Esther Gravatt, Jennie Crosson, Ruth Dodd, May Cottrell, Carrie Shibla, Nellie Hall, and Mattie Lewis; (second row) Mildred White, two unidentified students, Annie Shure, "Ron," Myrtle Anderson, and Florence White; (third row) unidentified, Paul Beutell, John Porter, Miss Bartine, Elmer Stokes, unidentified, and Anna Olsen; (fourth row) Claude Lawlor, unidentified, and Norman Lewis; (fifth row) George Smith, unidentified, Willard Petitt, and Arthur Parker; (sixth row) Harold Garrity and Uriah Mathews; (seventh row) Harry Marriner, Fred C. Hurley, Arnold Thompson, Arthur Garrity, Bill Howell, and Joe Shure. (Neptune Historical Museum.)

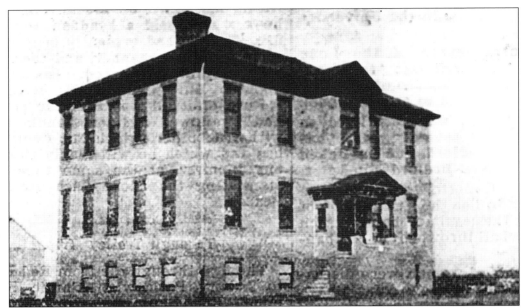

Bradley Park School is pictured in 1913, before the 1914 addition which added two wings to the original four-room building. Bradley Park School cost only $6,800 to build. Located on Tenth Avenue, it hosted students from kindergarten through eighth grade, later shifting from kindergarten through fourth grade. Bradley Park School was the first of Neptune's school to adopt a PTA in 1923. Beginning in 1939 Dr. Moulton and the board of education adopted a new policy of opening schools to the community, and Bradley Park teachers assisted township adults in shop projects (men) and crafts classes (women). Due to trailing attendance, the school building was closed in June 1986. (Neptune Historical Museum.)

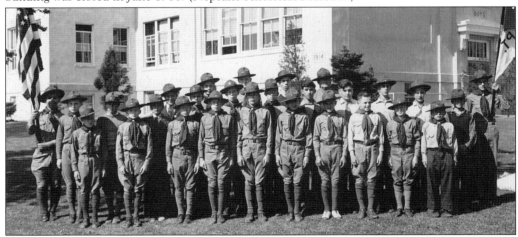

Boy Scout Troop 46 poses beside Bradley Park School in 1940. The Neptune Police sponsored this troop of 35 boys drawn from Bradley Park, Whitesville, Summerfield, Ridge Avenue Schools, and Neptune High School, beginning in 1939. The scouts were invited to meet at Bradley Park School by its principal, Mr. Warwick. Policemen Joseph O'Rourke (scoutmaster), Joseph Wardell, Walter Bangert, John Troppoli, and Thomas Orr were appointed by Police Chief William Maas and trained to be troop leaders. Boys in Troop 46 enjoyed archery and rifle shooting, among other scout activities. (Neptune Historical Museum.)

Ridge Avenue School was built in 1925 at a cost of $261,946. "Ridge" hosted a remarkable variety of student activities in the 1930s, including clubs for black history, gymnastics, puppetry, and photography. During World War II Ridge offered Neptune adult classes in home economics and crafts. The Ridge Avenue and Bradley Park PTA's—in cooperation with the township— also provided hot lunches to pupils and distributed holiday food packages to needy families. (Neptune Historical Museum.)

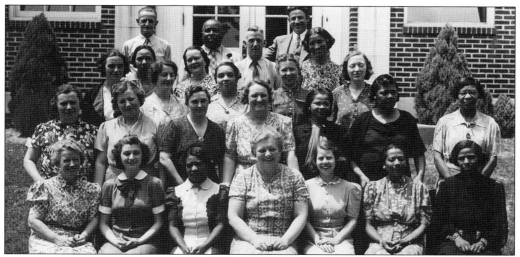

This was the staff at Ridge Avenue School in 1941. From left to right are: (first row) unidentified, Miss Farilla McKinnon (sixth grade), Miss Borden (principal), Miss Caroline Bartley (secretary), Miss Ressie Williamson (third grade), and Miss Neal (kindergarten); (second row) Miss Mary Dempsey (fourth grade, Ridge Ave. South), two unidentified persons, Miss Mildred Stickler (eighth grade, Ridge Ave. South), Miss Mary Henry (eighth grade, Ridge Ave. North), Miss Annabelle Eaton (second grade, Ridge Ave. North), and Miss Paine (janitress); (third row) unidentified, Miss Dolores de Garcia (art, grades six through eight), Miss Lolla Pratt (seventh grade), and Miss Grace Sutphin (sixth grade); (fourth row) Miss Bernice Withers (fifth grade), Miss Hicks (fourth grade), Mr. Rose (custodian), and Miss Victoria Rogers (first grade); (back row) Mr. Range (custodian), Mr. Asbury (principal), and unidentified. (Neptune Historical Museum.)

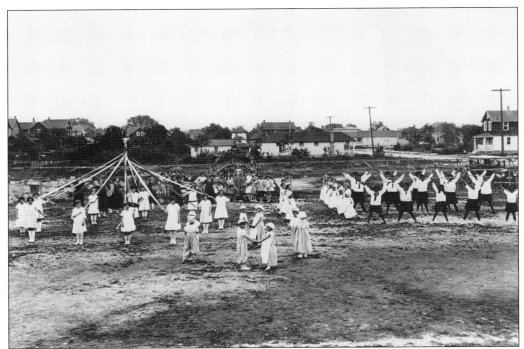

This 1920s May Day celebration at Ridge Avenue School would have warmed the heart of Busby Berkeley. Surrounding a bowered May Queen and her court (center) are 12 lasses weaving a Maypole with streamers (left), costumed dancers (foreground), and a middie-outfitted athletic team (right). (Neptune Historical Museum.)

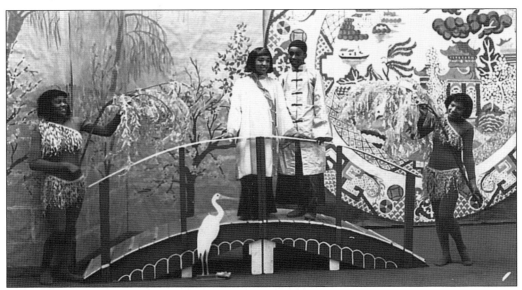

Miss Dolores de Garcia (teacher, grades 6,7, and 8) brought a rich world of art and theater to Ridge Avenue students. No effort was spared in creating sets, costumes, or productions. Ridge pupils' talents turned out a wealth of plays and musicales under her guidance, including this stage production of *The Willow Plate* in 1938. (Neptune Historical Museum.)

Six

SCHOOL SPORTS CHAMPIONS

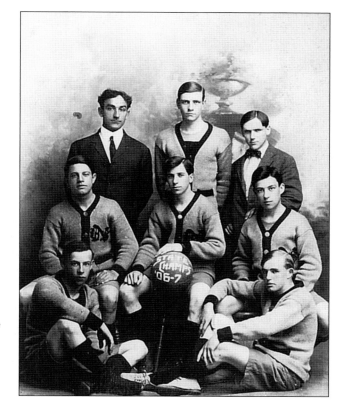

Shown here are the Neptune High State Basketball Champs of 1906–1907. From left to right are: (bottom row) Bill Bloom and Alred Rushton (forward); (middle row) Chester Gravatt (guard), Haddy Morris (forward), and Harold Simpson (forward); (top row) Dr. Cummings (coach), Ernest Messler (center), and Morton Morris (manager). Other state basketball championship years were 1949, 1981, and 1984. (Neptune Historical Museum.)

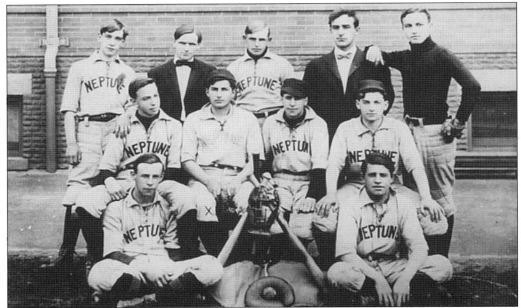

Neptune's 1907 Baseball Champs were, from left to right: (first row) Bill Bloom and Chet Gravatt; (second row) Ed Peterson, Bill Lyon, Naddie Morris, and I. Saches; (third row) LeRoy Hurford, Morton Morris (manager), Al Rushton, Dr. Cummings (coach), and Edward Wardell. Neptune captured the state baseball championship again in 1923. (Neptune Historical Museum.)

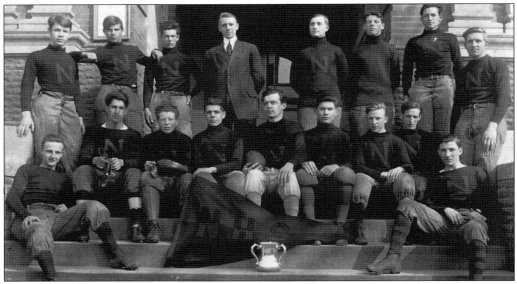

Neptune's Championship 1912 Football Team poses with its hard-earned trophy and banner on Neptune High School's steps. From left to right are: (front row) Leon Harris, Harry Lyon, Henry Cooper, Melvin Moore, Charles Barrett, Captain "Chief" Claude C. Newberry, William Bresvalian, Elliott Hough, and Fred Reichey; (back row) John Ryan, Booze Seymour, George Mathews, Dr. Murray Beck (manager), Raymond Gracey, Ernest Purcell, Jack Gifford, and Hollis Parker. (Neptune Historical Museum.)

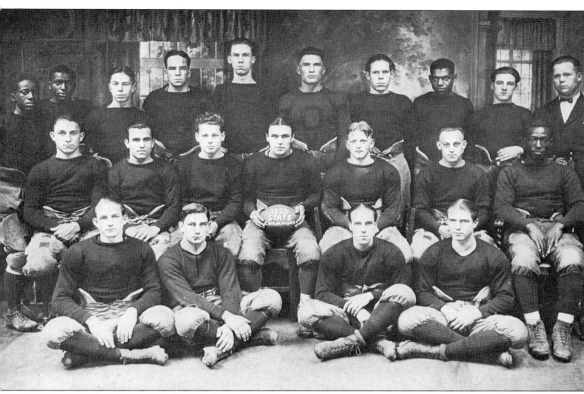

Pictured is Neptune High School's legendary unbeaten 1923 state championship football team. From left to right are: (front row) Beck, Moore, F. Smith, and Blair; (middle row) Newman, Capibianco, Schlossbach, Guinn (captain), Larson, Jaques, and Brown; (back row) Freeland, Lee, Holmes, Wilson, Shafto, Coach Newberry, Hulit, E. Smith, Reynolds, and Herbert (manager). Neptune High claimed the state football championship again in 1911, 1912, 1923, 1995, and 1996. (Neptune Historical Museum.)

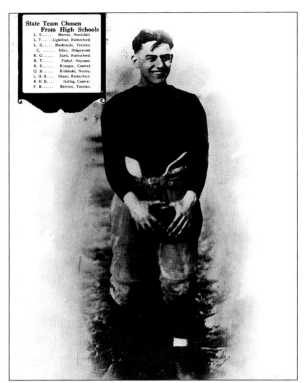

Sports heroes don't come any finer than Abe Finkel, Neptune High School, Class of 1924. Abe possessed exceptional prowess at all sports, but especially in football. He was elected to the All-State Team in 1920, was captain in 1922, and was slated to continue as Fliers' captain in 1923. In what appeared to be a politically motivated move, the state football board ruled Abe ineligible to play because he had played one minute of football in an eighth-grade game, putting him in excess of the four years of playing allowed. Mr. Finkel took the blow graciously and forfeited football his senior year, but lost his magic moment to have been captain of the unbeaten Neptune team that took the state championship in 1923. (Courtesy Abe Finkel.)

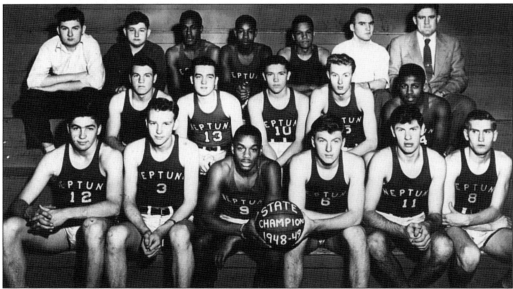

The 1948–49 Neptune High basketball team took the New Jersey State Championship and posed for a photograph on the high school bleachers. Team members are, from left to right: (front row) George Perkins, Mike Dolly, Jim Patterson, Joe Holmes, Ken Doremus, and Marv Atkinson; (second row) Walt Sargee, Bill Neaves, Roger Allgor, George Mauch, and Bobby Ingram; (third row) Joe O'Rourke, Manager Bill Zimmerman, Ozelle Jones, Tommy Ingram, A. Snead, Norman Clauson, and Coach Russ Coleman. (Neptune Historical Museum.)

Seven

FIREMEN AND FIRST AIDERS

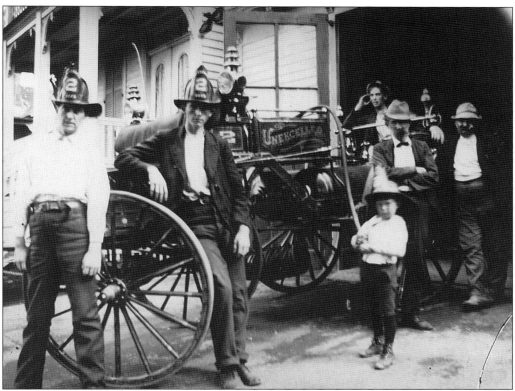

The Goodwill Fire Company—its name was changed a year later to the Unexcelled Fire Company—was formed in 1905. Unexcelled's first equipment was "a stripped down wagon with running gear carrying two painters ladders and several buckets." West Grove Methodist Church's bell sounded the fire call. A new firehouse was built in 1908, when the 1891 Unexcelled Fire House was moved to a lot on Corlies Avenue (west of Ridge Avenue) for use by the short-lived Uneeda Company. Uneeda Company merged with the Unexcelled in 1929. (Neptune Historical Museum.)

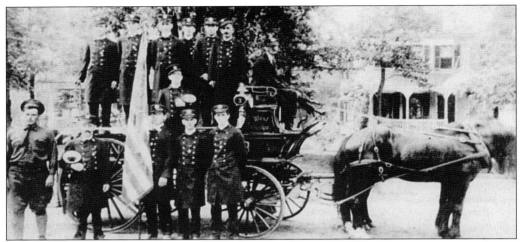

The men of the Uneeda Fire Company pose with Uneeda House Truck #3 in 1914. Uneeda was West Grove's first fire company, reportedly founded by disgruntled members of the Unexcelled Company in 1905. Given Uneeda Company's food-related moniker, they were nicknamed "The Biscuits." They changed their name to Dodd Fire Company #3 in 1918, then back to Uneeda Company in 1920. In 1929, Uneeda Company merged with the Unexcelled Fire Company. Firemen pictured, from left to right are: (on ground) Tilt Truax, Chief Elias E. Lewis, Armstead Parker, Harry Dodd, and Art Hurley; (on wagon) Harry McChesney, Joe Pullen, Cowrin (Pat) Dodd, John Peterson, Dolph Windsor, George Reynolds, and Ed Drum. Chief Martin Hurley stands in the center. (Neptune Historical Museum.)

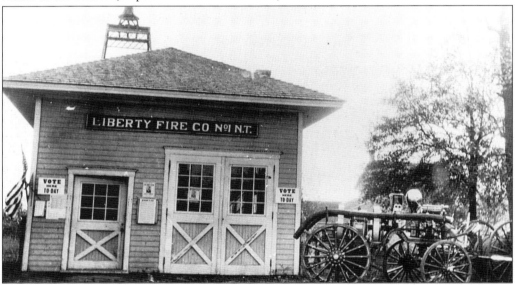

Whitesville's residents and businesses have been protected by the Liberty Fire Company since 1905, when Charlie Lane's Monroe Avenue stable housed their firewagon and hand-cranked hose-reel. In 1930 John Stetter and Matthew O'Hagan sold land on Monroe Avenue to Liberty Company, on which then built a (wooden shed) firehouse. This was replaced in 1930 by a new and larger firehouse. Early equipment acquisitions included a Reo chemical truck, a horse-drawn gasoline-driven pumper, and a Stutz 4-cylinder 350-gallon pumper. Liberty Fire Company is now a part of Neptune Fire District No. 1. (Neptune Historical Museum.)

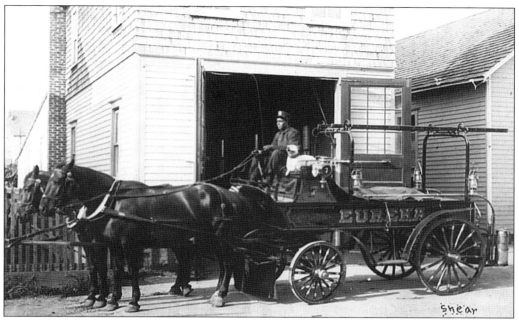

Neptune's only minority fire company, the Eureka company, included members of the Sand Hill Indian community. In this 1904 photograph Robert Richardson and Eureka's mascot fire dog staff the fire wagon at the Eureka Company's firehouse on old Springwood Avenue. The firehouse found itself out of the Neptune district when West Asbury Park was annexed from Neptune in 1906. It was torn down in 1915. (Neptune Historical Museum.)

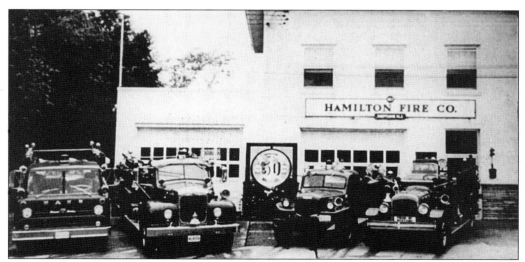

Hamilton Fire Company, organized in 1911, was first named the "John P.L. Tilton Fire Company No.1." In 1914 it was renamed the "Hamilton Chemical Fire Company," which was later shortened to "Hamilton Fire Company." This 1964 shot shows (from left to right) the company's 1961 Hahn 750-gallon pumper, a 1957 Mack 750-gallon pumper, a 1947 Dodge rescue unit, and a 1928 Seagrave 600-gallon pumper. (Neptune Historical Museum.)

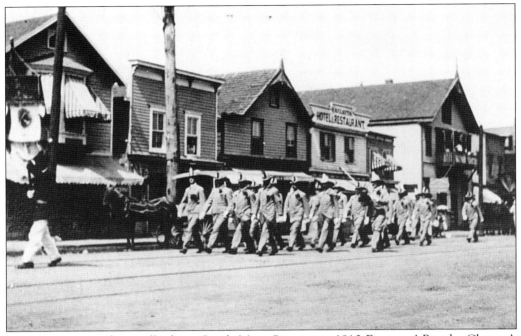

Area firemen march proudly down South Main Street in a 1910 Firemens' Parade. Clayton's Hotel and Restaurant can be seen in the background. (Neptune Historical Museum.)

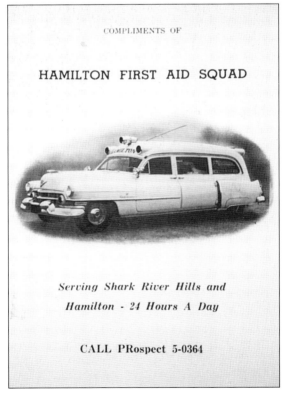

COMPLIMENTS OF

HAMILTON FIRST AID SQUAD

Serving Shark River Hills and

Hamilton - 24 Hours A Day

CALL PRospect 5-0364

The Hamilton First Aid Squad was formed in 1955 to serve the area whose name it bears. This 1959 booster ad shows the old La Salle ambulance once used by the Neptune Ambulance Corps, which became Hamilton's first piece of equipment. It was housed in John Stout's barn until an addition to the firehouse could be built for it. With Hamilton's population in a growth pattern, the squad found it necessary to construct its own first aid squad building on Route 33 and Jumping Brook Road in 1957. (Neptune Historical Museum.)

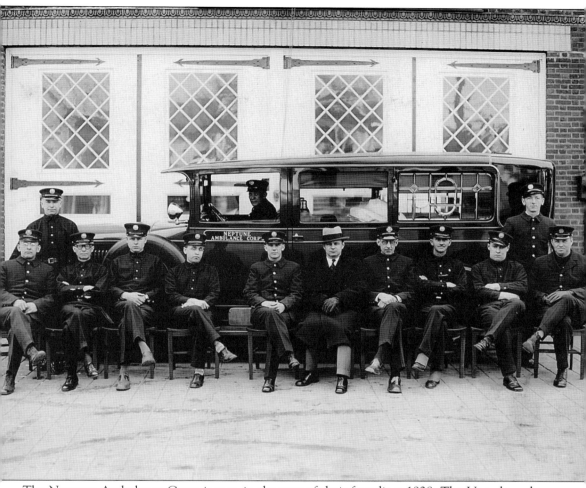

The Neptune Ambulance Corps is seen in the year of their founding, 1928. The Uneeda and Unexcelled Fire Companies originally organized this corps to offer first aid at fires. Its members came from Unexcelled, Hamilton, and Liberty Fire Companies, and it offered no-charge, 24-hour-a-day service. In 1949, the Neptune Ambulance Service came under the jurisdiction of the Neptune Police Force. Its new name: the Neptune Ambulance Corps. The 1928 Corps members included George White, Arthur Pharo, F. LeRoy Garrabrandt, Norman Lewis, Fred D. Hurley Jr., Dr. Sam Edelson, Claude Lawlor, Frederick Garrabrandt, Frank White, Kenneth Gravatt, Joseph Pullen, Charles Beerman, and Earl Lawlor. (Neptune Historical Museum.)

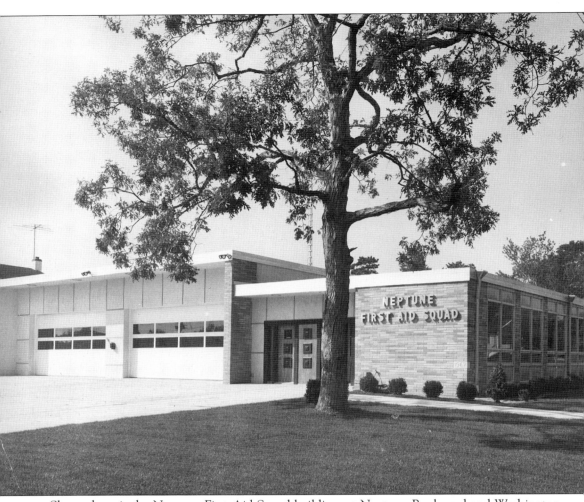

Shown here is the Neptune First Aid Squad building, at Neptune Boulevard and Washington Street. The Neptune First Aiders picked up where the Neptune Ambulance Service left off when that service ceased operations in 1949. NFA's original members came from the Unexcelled, Liberty, and Hamilton Fire Companies. The NFA served all of Neptune Township until 1932, when Ocean Grove formed its own first aid company. The Neptune First Aid building on Neptune Boulevard was dedicated in 1967. (Personal photo.)

Eight

NEPTUNE'S CHANGING SCENES

This is official correspondence to the 1867 Greenville Guards. A local militia was formed in 1862 in Greenville (the name for Hamilton in the mid-1800s). They called themselves the "Greenville Union Boys," but were officially the "Greenville Guards, Second Regiment, Monmouth and Ocean County Brigade." Saturdays they drilled before the flagpole at Trap Tavern. This group of 58 men existed until the end of the Civil War, when New Jersey's Quartermaster General Lewis Perrine directed Guards Captain A.H. Morris to return all arms to the state arsenal. (Neptune Historical Museum.)

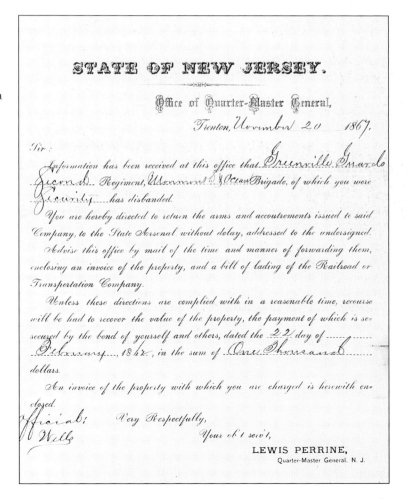

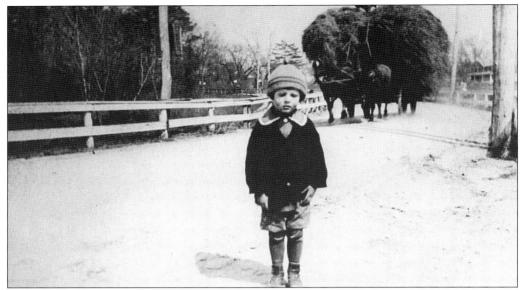

Little Nelson Palmer poses on the Van Brunt property near the Old Waterworks, in April 1918. The wagon seen behind him is carrying salt hay, a marsh grass which was used to insulate blocks of ice cut from frozen ponds in winter then stored in icehouses for use in warm weather. Cutting and selling salt hay was a major industry all along the shore area but disappeared when artificial refrigeration rendered the kitchen icebox obsolete. (Neptune Historical Museum.)

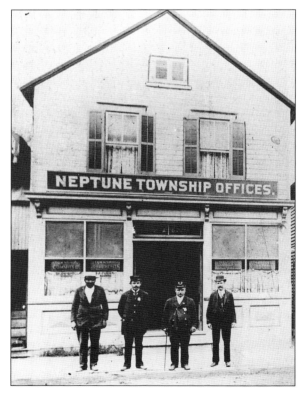

This rented building at 47 South Main Street served as Township of Neptune Municipal Offices from 1897 to April 1906. Pictured, from left to right, about 1905 at the offices are employees "Post Hole Joe" Robinson (janitor), Walter H. Gravatt (policeman, later tax collector, then Monmouth County Sheriff), Jacob Preston (police chief), and Peter F. Dodd (magistrate). The township relocated municipal headquarters frequently from 1906 to 1923, renting offices at Asbury Avenue and the railroad in Asbury Park (April–December 1906), at Corlies Avenue and the railroad in Neptune (1907–1912), and at 75 South Main Street (1912–1923). (Neptune Historical Museum.)

A lady in proper afternoon attire and parasol crosses a sleepy Corlies Avenue *c.* 1902. The sole traffic at this intersection appears to be a horse-drawn street sprinkler. Lazily lumbering along, its driver and his spotted dog share the wagon bench beneath an umbrella which advertises "Dr. Daniels' Medicines." (Neptune Historical Museum.)

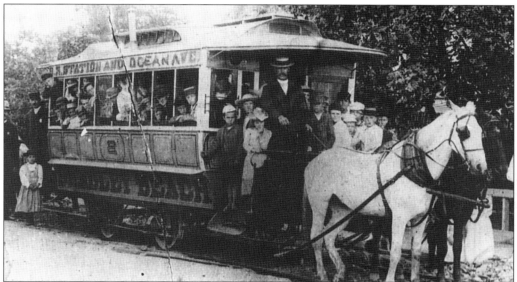

The Asbury Park and Belmar Railway Company's trolley line began where the Sea Shore Electric Railway's streetcar franchise ended (Asbury Park's southern city line), and ran from Main Street to the Shark River Bridge. On June 23, 1893, the first day of operations, James Bradley initiated service by treating local children to the historic ride which ran from Asbury's line to Bradley Beach's Sylvan Lake. The streetcar was borrowed from Sea Shore Electric Railway and drawn (for a nostalgic touch) by horses, though the line was electrically powered. Trolleys later transported Neptune's Bradley Beach school pupils to school here at a reduced fare of 3¢. The streetcar lines were gradually phased out, with remaining service ceasing entirely in 1931. (Joseph Eid Collection.)

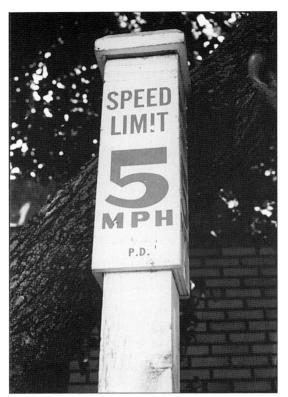

A wooden traffic sign posts a speed limit that puts motorcars at par with horse-drawn vehicles. Heavy traffic, still a fact of life in Neptune, may have been the impetus behind the need to create an official Neptune Police Force in 1910. In 1884 Neptune law enforcement consisted of four men: Police Chief R. TenBroeck Stout (serving without pay), and officers S.R. Miller, John Dobson, and E.H. Watson. Patrolmens' pay was $60 a month. It wasn't long until motoring vacationers generated community petitions protesting high traffic volume and out-of-town motorists ignoring the speed limit. In October 1910, the township committee saw the writing on the roadway and adopted an ordinance creating a police department. (Neptune Historical Museum.)

This trestle bridge, built by the county about 1925, spans Jumping Brook on Old Corlies Avenue (County Route 17). Officially it is known as "NJ Structure No. 13000N5" and is a "22-span, multi-stringer trestle with concrete grilled grating, bent piers and concrete abutment." The 202-foot, two-lane bridge's charm comes from its wrought-iron side rails, which create a distinctive lace-like appearance. Now in poor structural condition, the bridge is slated for demolition and replacement in 1999. (Personal photo.)

Neptune Gables, as it is known today, was originally Asbury Gables, "Twixt Tee [Jumping Brook Country Club] and Sea." It was the second 1920s-era real estate project launched by Morrisey and Walker. The site chosen was the vicinity of Elisha Slocum's farm near Walnut Street, known for its bountiful fruit trees and berry bushes. Sight-seeing buses lured prospective buyers to look at the "National Model Home" designed by William F.B. Koelle. (Neptune Historical Museum.)

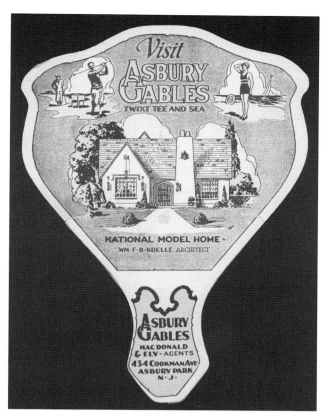

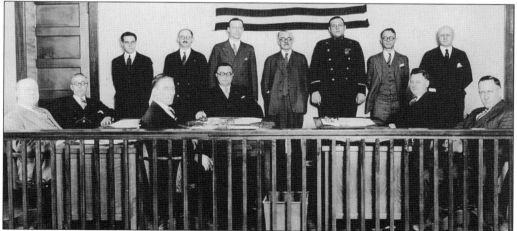

The fifth location for the Township of Neptune Municipal Offices was at 137 South Main Street (mid-1920s to 1971). This interior shot, dated March 15, 1929, shows township officials. From left to right are: (seated) Charles S. Loveman (road committee chairman), John S. Hall (finance chairman), John W. Knox (clerk and executive manager), Raymond R. Gracey (chairman), Ralph Johnson (light, poor, and publicity chairman), and Harry Whitlock (police committee chairman); (standing) Stanley Applegate (health officer), Frank Reynolds (auditor), Richard W. Stout (solicitor), Peter F. Dodd (recorder), William Maas (police chief), Arthur A. Pharo (treasurer), and Harry G. Shreve (assessor). (Neptune Historical Museum.)

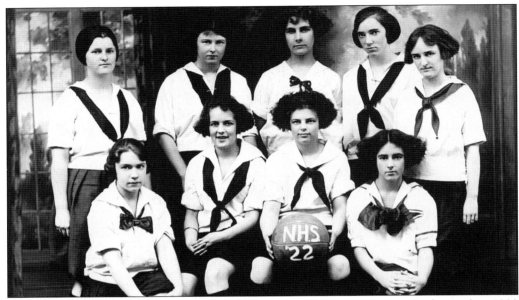

The Neptune High School Girls Basketball Team affects a serious attitude in this 1922 team portrait. Team members were, from left to right: (front row) Ethelyn Goodyear, Myrtle Applegate, Captain Grace Purchase, and Ruth Pine; (back row) Lillian Hunt, Lydia Rogers, Carolyn Keast, Elizabeth Height, and Hazel Wooley. (Neptune Historical Museum.)

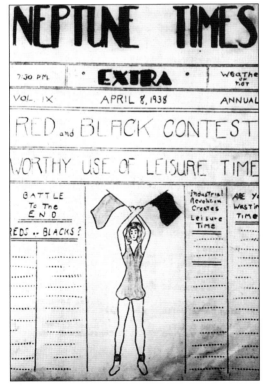

A student-made flier touts a 1938 Red and Black contest. The Girls Athletic Association (GAA) was founded in 1932 by Miss Elizabeth Adams, supervisor of health and physical education for Neptune Township Schools. The GAA provided sports opportunities for girls within an otherwise male-dominated sports curriculum. Girls entering high school were placed in either a red or black team, with whom they remained for their high school careers. Each team had its student chairman, and employed squads for stunts and cheerleading. The annual Black and Red contest enjoyed enormous community popularity, and involved a variety of sports events—from basketball to volleyball to Zell ball—and a trophy was presented to the winning team. A yearly Mother-Daughter Banquet was a greatly anticipated event. With girls' sports an accepted part of regular school athletics, and with GAA enrollment declining, the last Red and Black game was held at Asbury Park's Convention Hall in 1985. The Reds won, 39–29. (Neptune Historical Museum.)

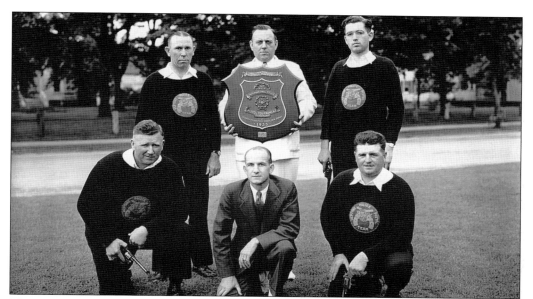

The 1935 Neptune Police Pistol Team champions are shown here. In the 1930s Neptune's team held not only the pistol team championship for the state of New Jersey, but the international title as well. Their practice range was next to the old Asbury Park Air Terminal at Jumping Brook Road and Route 66. With the completion of the current Municipal Building in 1971, a modern firing range patterned on FBI specifications was opened in the building's basement. Team members pictured here are, left to right: (kneeling) Jim O'Rourke, Township Recorder Ross Beck, and Walter Bangert; (standing) Harry Low, Police Chief William Maas, and Joseph Wardell. (Neptune Historical Museum.)

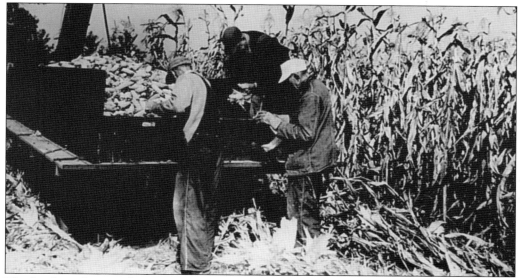

The brothers Stout, John B., Samuel, and Fred, harvest feed corn on their Hamilton farm in 1959. Farming was still a common way of life locally despite the encroachments of modern development, and farmers commonly brought produce—potatoes, beans, corn, squash, peppers, lettuce, turnips, rhubarb, and berries—to Stone's Market on Springdale Avenue to be sold. (Courtesy Virginia Stout Thompson.)

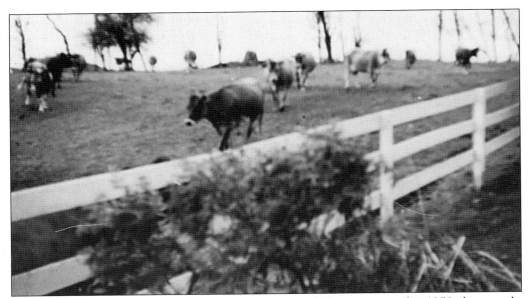

Grazing cows evoke pastoral serenity at the Ernest Smith Farm, seen in this 1958 photograph. The farm was located where Route 66 and Asbury Avenue diverge. The 1963 auction of the Ernest Smith Farm really marked the end of over 100 years of farming tradition in Neptune. Remaining farmers were up in years by then, and members of the next generation, many college educated, chose professional careers over farming. Land parcels sold off gradually to developers and businesses, leaving homesteads like islands as farm acreage shrank around them. (Neptune Historical Museum.)

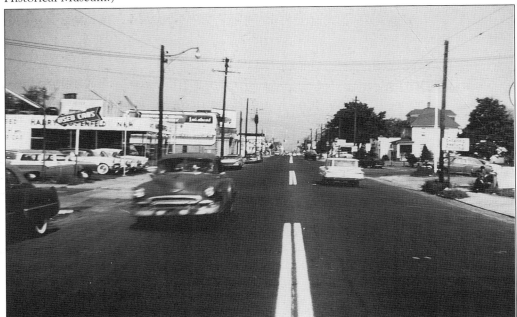

Neptune's version of the "Miracle Mile" is shown here in the early 1960s. Looking north up South Main Street towards Asbury Park, motorists pass Harry Rosenfeld's Used Car lot which features enough vintage cars to make a collector's mouth water. (Neptune Historical Museum.)

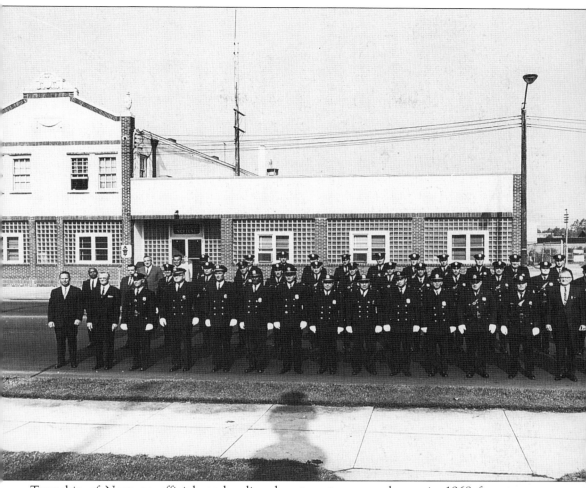

Township of Neptune officials and police department personnel pose in 1968 for a group photograph in front of 137 South Main Street, Township Municipal building from the mid-1920s to 1971. From left to right are: (front row) Det. George Jobes, Det. Cpt. Alf Atkinson, Ptl. Alfred Hurley, Sgt. Ed Reid, Sgt. Willis Atkinson, Lt. Robert Woodbridge, Cpt. Walter Gilbert, Chief A. Le Roy Ward, Lt. John Troppoli, Lt. Kenny Smith, Sgt. Bud Thompson, Ptl. Bud De Vay, Ptl. Angelo Diglio, Committeeman Herman Johnson, and Judge Jim Laird; (second row) Det. Pee Wee Lyons, Det. Ray Hulse, Ptl. Bill Heaves, Bob Kirby, Jim Ward, Tony Paduano, Ernie Smith, Will Hulse, Paul Petro, Anthony Petro, Carmen Di Chara, Glenn Trout, Ralph Hoffmann, and Gary Hill; (third row) Sgt. Arnold Moore, Det. Vinny Martin, Ptl. Dave Johnson, Ptl. Ray Horner, Ptl. Warren Scott, Ptl. Louis D'Anna, Ptl. Richard Measure, Ptl. Don Steadman, Ptl. Robert Sargusa, Ptl. Charles Scott, Ptl. Marvin Atkinson, Ptl. Bobby Smidt, Ptl. Ellsworth Matthews, and Ptl. Leon Williams. (Neptune Historical Museum.)

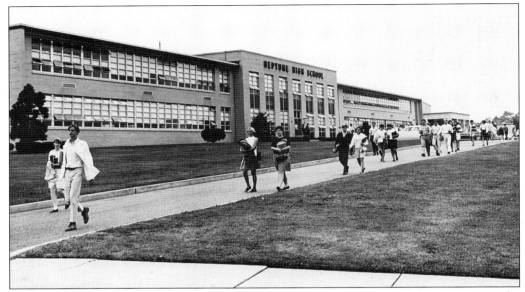

Students trek down the path of the current Neptune Senior High School, built in 1960. The land on which this school stands was once the Knight farm. Old-timers recall the large clay mound which stood 100 feet high on the property, offering haven to a large population of swallows. Neptune Senior High cost $3,010,670 and was designed by Victor Ronfeldt. (Neptune Historical Museum.)

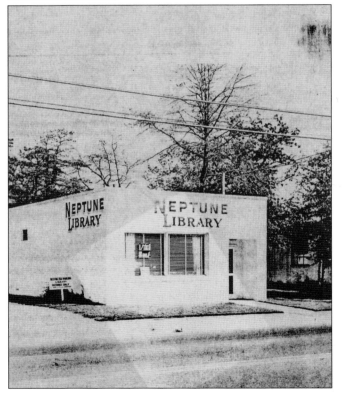

In 1924, the Neptune Public Library began operations on a modest scale—a bookshelf in the Ocean Grove Woman's Club. It was relocated to the township's Welfare Office, then to this former welding shop (later Yates Sign Company) on Corlies Avenue in 1961. The library took up its present residence within the Township Municipal building when it opened in 1971. The library elected to remain independent of the county library system in 1972. In 28 years, under Director Alan A. Heinlein, the Neptune Public Library has grown to offer over 70,000 books, 2,000 audio tapes, and 4,000 video tapes. Its active children's and adult departments enjoy an annual circulation numbering 150,000. (Neptune Historical Museum.)

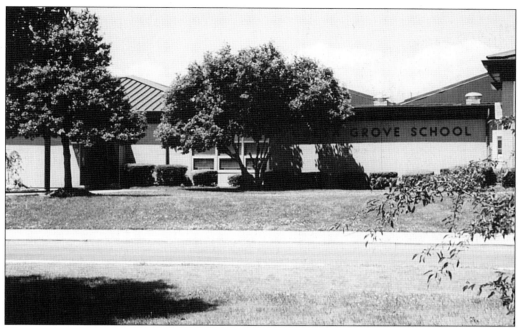

The modern lines of Green Grove School (kindergarten through fourth grades) echo the aesthetics of the era in which it was constructed. Built in 1963, it was designed by architects J. Stanley Sharp and Arnold Pantel. Its general contractor was Sutherland Backer Company, and its construction was completed for $774,000. (Neptune Historical Museum.)

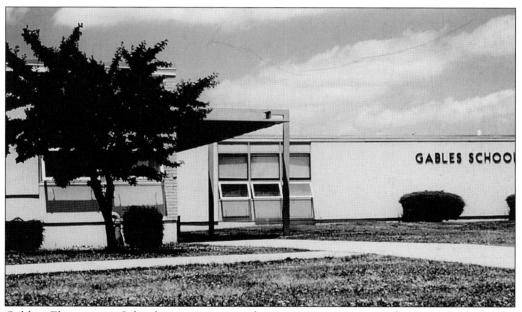

Gables Elementary School was constructed in 1963 to accommodate pupils from the neighborhood around the Gables housing development. Sharp and Hedron were architects for its design, and its cost for construction was $412,057. (Personal photo.)

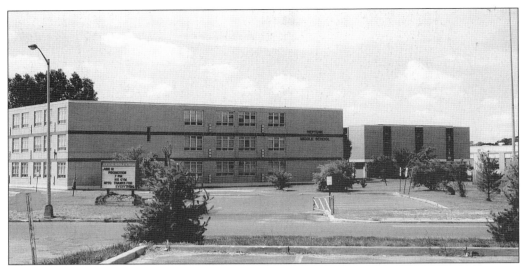

The new Neptune Junior High School facility opened in 1967 at 2300 Heck Avenue. Intermediate grades had been attending classes at the old Neptune High School building since 1961. Architects Sharp and Handren designed the building, which cost $2,842,058 to construct. When it opened, it was the largest junior high school in New Jersey. Built the same year as Gables School, the two schools shared a joint dedication ceremony on December 3, 1967. (Personal photo.)

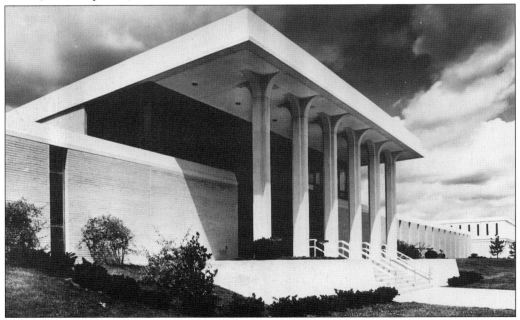

The dramatic lines of the current Township of Neptune Municipal building evoke a modernized classicism. Built in 1971, the complex at 25 Neptune Boulevard represented the first time township offices were not in rental quarters. The white complex of brick and pre-cast concrete cost $2.6 million to construct and contains the township administrative offices, police department, public library, and Neptune Historical Museum. Dedication ceremonies took place on May 1, 1971. (Neptune Historical Museum.)

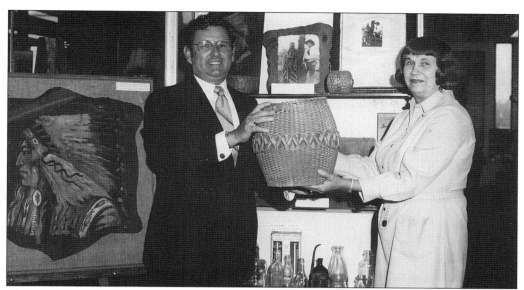

The Neptune Historical museum's founder and first curator, Peggy Goodrich, accepts a basket made by Margaret Lopez, grandmother of donor Joseph Lopez (left). The Neptune Historical Museum opened at the new municipal complex in 1971, after a brief summer stint at the Merry-go-round house in Ocean Grove in 1964. Many of its artifacts and memorabilia were donated by the Neptune Historical Society, which had been founded three years earlier. Exhibits pertaining to the history of Neptune, Ocean Grove, and Shark River Hills are displayed at the museum, with archives, a reference library, and tours available to the public. The museum is supported by the Township of Neptune. (Neptune Historical Museum.)

"Project Quack Quack" was not your usual rescue mission for Neptune's Public Works Department and the board of health. The flock of mallard and muscovy ducks, raised by Ike Schlossbach at his Jumping Brook Airport, needed more care than Ike's busy lifestyle could provide. In 1967 township workers rounded up the ducks and transported them to Lake Alberta where—with their wings clipped—they found a new home. Here they stroll on the lawn of nearby senior housing. (Neptune Historical Museum.)

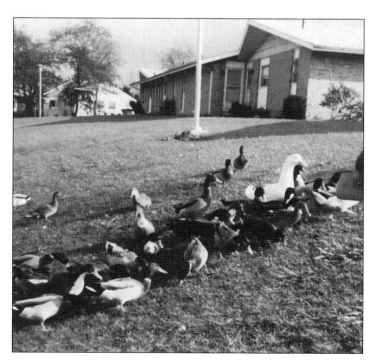

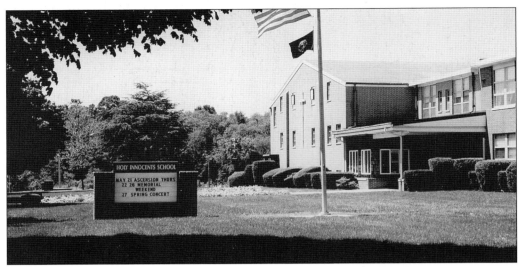

Holy Innocents School opened in October of 1965 on the site of the old Elmer Farm, on West Bangs Avenue and Route 33. The building contains 16 classrooms, a library, audio-visual room, staff rooms, and a cafeteria. A church and convent occupy the hilltop site with the school. (Personal photo.)

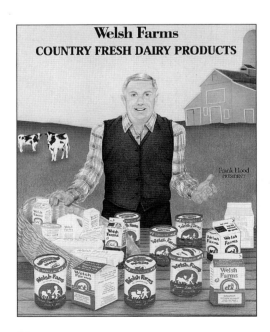

Welsh Farms took over the old Wardell Dairy operation in Neptune in 1970. Following the same practice as Wardell's during its growth phase, Welsh Farms bought out existing dairies where home delivery routes were already established. Welsh Farms expanded business to include wholesale routes which now stretch from its original home plant in Pleasant Valley, New Jersey to Newark, Delaware. 13 home delivery trucks and 14 wholesale trucks operate out of the Neptune facility. Welsh Farms serves over 7,000 customers, primarily in Monmouth and Ocean Counties. (Courtesy Welsh Farms.)

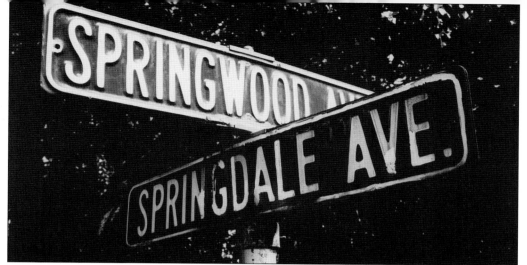

A street sign marks the intersection of the former Springdale and Springwood Avenue in Neptune. On June 1, 1973, 75 years of tradition ended when Springdale Avenue's name was officially changed to Neptune Boulevard. The name change was part of a state-funded "Safe and Clean Neighborhood Program," which provided Neptune with $316,000 to upgrade the municipality's business and cultural operations. The cross street, Springwood Avenue, was a widely patronized shopping district comprised of locally owned minority businesses and a farmer's market until the late 1960s. Changing time brought riots to the street, and the business area never fully recovered its economic vigor. Springwood's name was changed to West Lake Avenue on the Neptune terminus of the thoroughfare in 1979. (Neptune Historical Museum.)

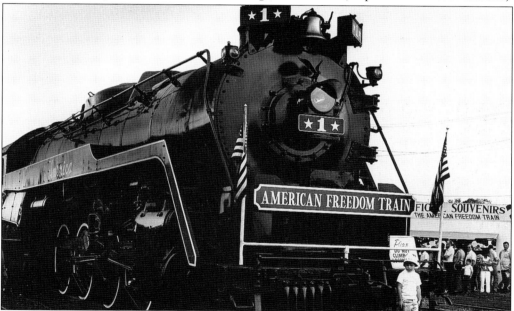

The American Freedom Train, a centerpiece of the 1976 U.S. Bicentennial Celebration, stopped at the Neptune/Bradley Beach railroad siding from September 2 through 6, 1976. Over 60,000 persons boarded the train here to view a plethora of artifacts and exhibits related to our country's achievements over the last 200 years. The 24-car national museum offered everything from sacred American icons (Lincoln's original Gettysburg Address) to pop-culture memorabilia (basketball star Bob Lanier's size-20 sneaker). (Courtesy Milton Edelman.)

You are cordially invited to attend the

Dedication Ceremonies

of the

Township of Neptune
Senior Citizens' Center

1825 Corlies Avenue • Neptune, N.J.

Saturday, May 5, 1990

1:00 P.M. — Presentation of the Colors
Dedication of Flag and Flagpole
by American Legion Post 346,
Neptune

1:15 P.M. — Formal Dedication Ceremony
followed by refreshments

RSVP by April 27, 1990 988-8855

An invitation marks the May 5, 1990 dedication of the Neptune's Senior Center, at the corner of Route 33 and Neptune Boulevard. Senior services had operated from the VFW Hall, the Davis Avenue Senior Housing, and Sebastian Village before finding a permanent home in this multi-purpose modern building. Under the directorship of Rosemary Gray since 1987, the Neptune Senior Center today has grown to serve over 7,000 men and women. The complex provides a full range of services including daily hot lunches, social services, health screenings, home support services, and senior transportation, as well as instructional and recreational programming. (Neptune Historical Museum.)

Nine
LANDMARK ATTRACTIONS

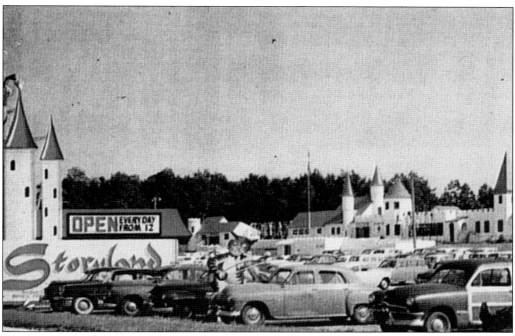

Storyland Village—"A Child's Garden of Verses and Stories" where "favorite stories come to life"—was a family favorite for locals and tourists alike. It opened in 1955 on Route 66 (site of a present-day Caldor store). Storyland's attractions were housed within a gleaming white castle-like enclave, topped with bright red spires. Linked by paths, 23 magical Mother Goose tales came to life for kids in colorful attractions designed by Russel Patterson. Visitors could dine at King Arthur's Court, pet the sheep at Bo Peep's house, or have their photograph taken with "Jerry the Clown" (Raymond H. Revel). Admission was 85¢ for adults and 35¢ for children, and the park was open year-round. As the 1950s drew to a close, the general public's taste in recreation developed a new sophistication, and the change seemed to drain Storyland Village of its magic and profits. Many felt they had lost a part of their childhood when those gates to King Arthur's Court closed in 1962. (Neptune Historical Museum.)

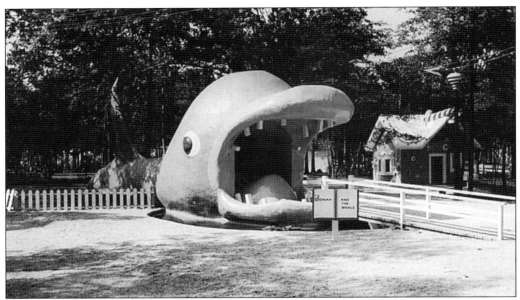

This whale's gaping maw never terrorized youngsters who happily climbed in and out of his mouth at "Jonah and the Whale." Some attractions at Storyland were built specifically to encourage children to climb on and about them. Visitors loved clambering into the shell of Peter Pumpkin Eater, or entering the house of the "Old Woman Who Lived in the Shoe." Kids could also cut loose at "Margery Daw's Play Ground," where their playful squealing never bothered "Sleeping Beauty," who lived next door. (Neptune Historical Museum.)

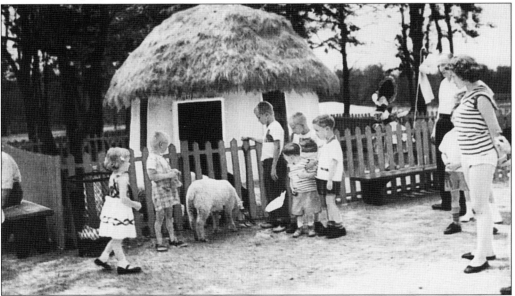

Bo Peep's Sheep and many other creatures interacted with visitors to Storyland. Offered for sale were cornballs to feed to the park's animals at "Rabbitland," the "Deer Park," or the corral, which housed imported Sicilian donkeys. The residents of the "Monkey House" could be relied upon for crowd-pleasing antics, but weren't available for feeding or petting. (Neptune Historical Museum.)

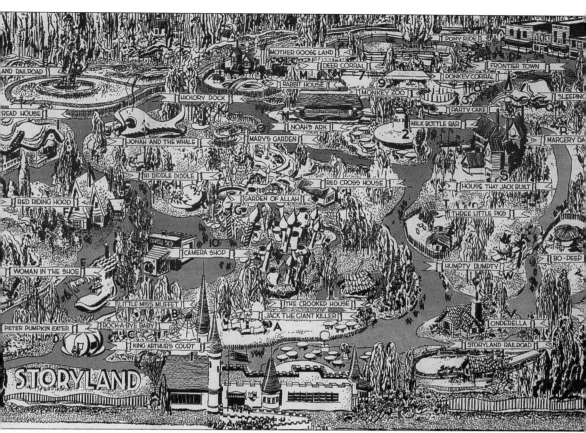

For baby-boomers who visited Storyland as youngsters, this visitor's map of the Village and its many attractions is a walk down memory lane. (Neptune Historical Museum.)

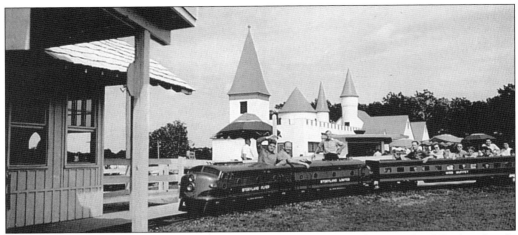

Featuring a miniature of the famous train the "Silver Meteor," the Storyland Railroad rode visitors around the perimeter of the Village. Riders entered and exited from the park's bright yellow miniature train station. Rides were 25¢ or 2 for 35¢. (Neptune Historical Museum.)

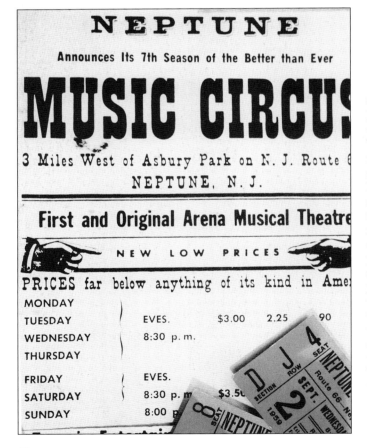

Greasepaint and bright lights came to Neptune via the closed Asbury Park Air Terminal site beginning in 1952. Renting a hilltop at the corner of Jumping Brook Road and Route 66, showman St. John Terrell replaced its wheat and corn fields with a gaily striped circus tent set over a seating pit. Amidst a circus-theme atmosphere he churned out popular musical comedies to the delight of theater-goers who came to experience theater-in-the-round and an al fresco atmosphere in this unique form of theater. The curtain came down on the Neptune Music Circus in 1959, when it finished its last season. (Neptune Historical Museum.)

St. John ("Sinjin") Terrell founded the Neptune Music Circus in the early 1950s and revolutionized summer show business. "Sinjin" brought with him a theater background, beginning as a carnival fire-eater at age 16. He was the voice of radio's "Jack Armstrong, All-American Boy," acted in Shakespearean roles, and was a founder of the Bucks County Playhouse in New Hope, Pennsylvania. Besides serving as a WW II flyer, he had toured with USO troupes, and had run a summer theater in Connecticut. "Sinjin" Terrell knew what theater-goers liked, and its name was "The Neptune Music Circus." (Neptune Historical Museum.)

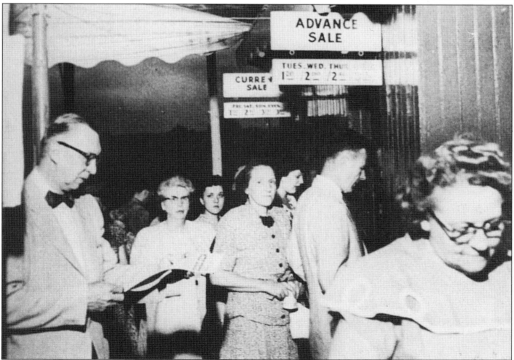

These 1950s theater-goers line up at the ticket window outside the Music Circus. The production might have been any popular Broadway adaptation. A 1957 show schedule lists *The Pajama Game, Oklahoma!, South Pacific, Plain and Fancy, On The Town, Hellzapoppin' '57, The Boyfriend,* and *Mr. Roberts*. (Neptune Historical Museum.)

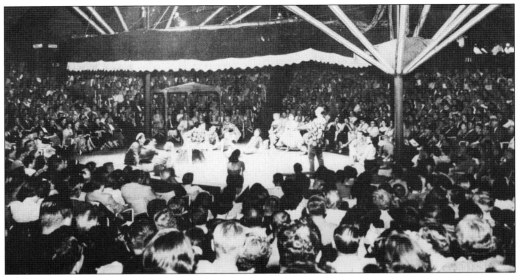

The stage of the Neptune Music Circus was designed for theater-in-the-round. Aisles ran from the tent's perimeter to the stage like spokes in a wheel, with seats in ever-growing concentric rows outwards. The elements could be fickle and provide a sultry atmosphere or an unexpected chilly night for ticket holders, although few minded. Occasionally a performance was called off due to an uninvited skunk's interest in the evening's performance. (Neptune Historical Museum.)

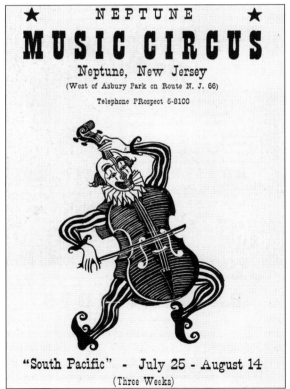

An evening's program for a Music Circus performance of *South Pacific* carries a handwritten note: "Dot and Walt went August 9, 1955." Since the program was kept over 40 years, the night's performance must have been well received and long remembered. In this production, the role of "Lt. Buzz Adams" was played by an unknown named Robert Goulet. (Neptune Historical Museum.)

The main terminal building of the Asbury Park Air Terminal is seen across the property's duckpond. The pond is fed by springs from Jumping Brook. It served as the test site for an experimental flying submarine (pond water in the sub's tail dragged it to earth after an initial good takeoff) and as a home for Ike Schlossbach's pet ducks. (Courtesy Milton Edelman.)

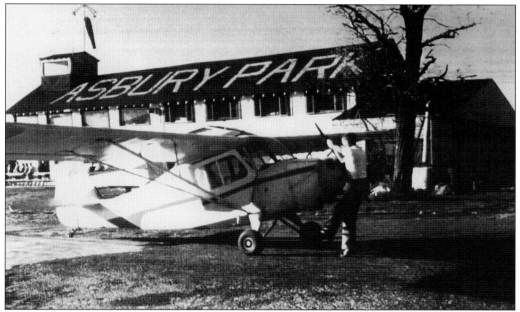

A mechanic starts the propeller at the Asbury Park Air Terminal, c. 1955. The 125-acre property was purchased as a farm by retired Navy Commander Ike Schlossbach in 1935, and opened as an airport in 1938 under Ike's Jersey Aero Club. During WW II, the airfield trained 30 military flying instructors, and at the war's close, Ike ran it as a commercial airport called the Asbury Park Air Terminal. It was one of the first airports in central Jersey. Ike began leasing out the property in 1948. From 1952 to 1959 it was used for the Neptune Music Circus. Meanwhile the airport operated under Richard M. Davis and saw the addition of the Gibson Air Academy about 1966. The airport buildings were demolished in 1979, and the US Life Building occupies the site today. (Courtesy Milton Edelman.)

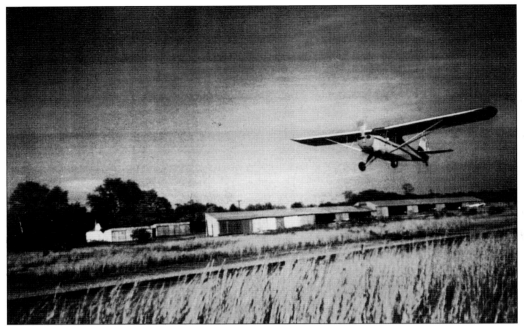

A private plane comes in for a landing on Asbury Park Air Terminal's runway, beside airport hangars and waving field grasses. (Courtesy Milton Edelman.)

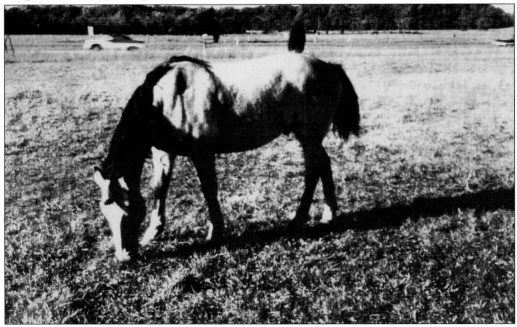

Commander Schlossbach's pony, Pinky, grazes at the Asbury Park Air Terminal in Neptune. Pinky had full run of the airport, and fliers wanting to take off or land on the runways simply had to wait until Pinky was ready to relinquish the space. In Ike's world, planes deferred to pet ponies, and nobody at the airport seemed to object to the eccentric operating procedure. (Courtesy Milton Edelman.)

Ten

FAMOUS FACES

Navy Commander Isaac ("Ike") Schlossbach is shown on expedition to Antarctica with Admiral Byrd in 1937. Born in 1891, second oldest of nine children, Ike helped run the Schlossbach Dry Goods store at 37 South Main Street. Graduating from Neptune High in 1909 and the U.S. Naval Academy at Annapolis in 1915, Ike figured prominently in early navy submarine development and in crafting what became the Naval Air Force. He was also an instructor at Annapolis. Losing an eye forced Ike to retire from the navy in 1930, but retirement only marked the beginning of an adventure-filled future which included nine antarctic and three arctic expeditions, plus a stint exploring Honduras' Patuca River. "Retiring" to Neptune in 1938, he purchased the old Sculthorpe farm at Route 66 and Jumping Brook Road. He operated an airport and flying school there until 1966, when it became the Gibson Air Academy. In 1984, at age 93, Ike Schlossbach—intrepid explorer and adventurer, three-time Congressional medal holder and entrepreneur, survivor of four airplane crashes and two automobile accidents—died peacefully in Sunshine Manor Nursing Home. (Neptune Historical Museum.)

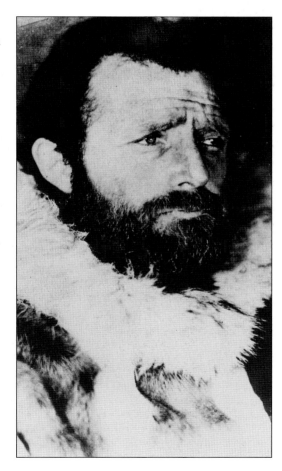

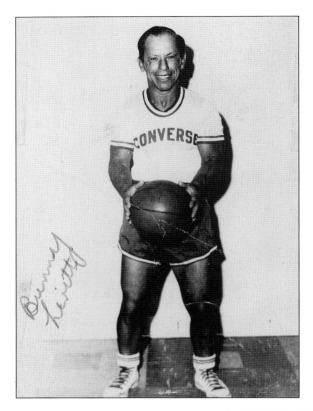

Basketball's world free-throw champion, Bunny Levitt, successfully shot 499 consecutive free-throw baskets in 1959 to earn a place in the *Guinness Book of World Records.* (He missed the 500th shot, but then proceeded to complete 386 more perfect basket shots.) Known as "The Ambassador of Basketball," Bunny later entertained spectators for years as a member of the Harlem Globetrotters before becoming a spokesman for Converse sports products. (Neptune Historical Museum.)

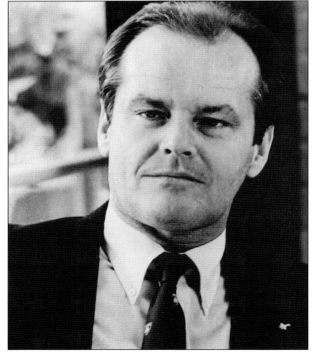

Hollywood's "Bad Boy," Jack Nicholson was born on April 22, 1937, at Neptune's Fitkin Hospital (now Jersey Shore Medical Center), and lived his first eight years in Neptune. Home was 1601 Monroe Avenue and later, 1410 Sixth Avenue, Neptune. Jack was raised by his grandmother, Ethel May Nicholson, who ran a hairdressing business out of her home. His grandfather, John J. Nicholson, was a prize-winning store window-dresser for the area's Steinbach department stores. Jack's mother, June Nicholson, was busy trying to launch a stage career as a dancer, and carried on her life away from the family. (Courtesy Billy Smith.)

Quarterback Bob Davis, "college football's greatest scrambling quarterback," is seen here as New York Jets' #12. Bob distinguished himself at Neptune High as an All-State, All-County, and All-Shore football and basketball star. Graduating from Neptune in 1963, Bob broke a slew of college football records playing for the University of Virginia's football Cavaliers, where he was the Atlantic Coast Conference's Player of the Year, won the Robert B. Smith Award for Outstanding College Player (Washington, D.C. area), and set the 1964 game record for total offense (334 yards). Bob was chosen for the Atlantic Coast All Conference Team and was voted their MVP. He holds 13 college and nine ACC records. He was the number two draft choice for the Houston Oilers in 1967, then continued to thrill crowds quarterbacking for the New York Jets (1967–69), New Orleans Saints (1973), the (now defunct) World Football League (1975), and the Philadelphia Eagles. Mr. Davis currently is a vice-president for Sun National Bank. His volunteer work with youth groups and civic organizations in Monmouth County has earned him numerous awards for his humanitarianism. (Courtesy Bob Davis.)

Professional wrestling's "Bam Bam" (Scott) Bigelow (Neptune High School graduate) has competed for the World Wrestling Federation as well as the New Japan Pro Wrestling team. He has been matched against Japan's sumo wrestling champ and with football star Lawrence Taylor on "Wrestlemania." "Bam Bam" has held the "Heavyweight Extreme Championship Wrestling Belt" as well as the "TV Championship Belt," and is well known as a member of professional wrestling's "Triple Threat Team." Mr. Bigelow has hosted TV's "Candid Camera," and has acted in two motion pictures. He lives with his wife and two sons in Ocean Township and is active in charity work for the Asbury Park Elks, the Diabetes Foundation, and Vietnam Veterans groups. (Courtesy Dana Bigelow.)

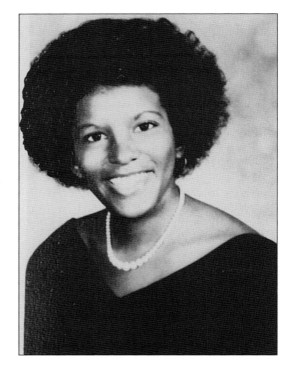

Television news journalist Pat Battle brings breaking stories to metropolitan area audiences on WNBC-TV. A 1977 graduate of Neptune High School, Pat is pictured in her yearbook pose with class activities listed as Dolphins (Cheerleaders), Black Studies Club, and GAA (Girls Athletic Association). Currently, Pat covers television news in Philadelphia and New York. Pat's Mom, Almerth Battle, served as township committeewoman and police commissioner in the 1970s. (Neptune Historical Museum.)

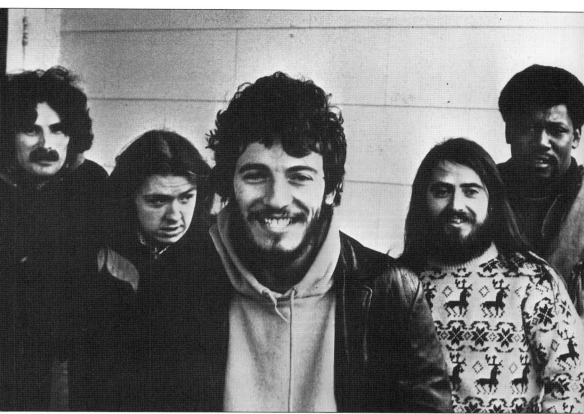

It's young Bruce Springsteen (center), surrounded by his famous "E Street Band" in 1973. Neptune talent drove the band's rhythm section, in the form of drummer Vini "Mad Dog" Lopez (far left), and bassist Garry Talent (to Bruce's right), both Class of '67 Neptune graduates. Lopez played in Bruce's early bands and on his first two albums. He has also backed the Beatles and the Rolling Stones. Gary is heard on all of Bruce's albums. The "E Street's" remaining rockers pictured are (to Bruce's left) guitarist Gary Federici and (far right) sax legend Clarence Clemons. (Courtesy Billy Smith.)

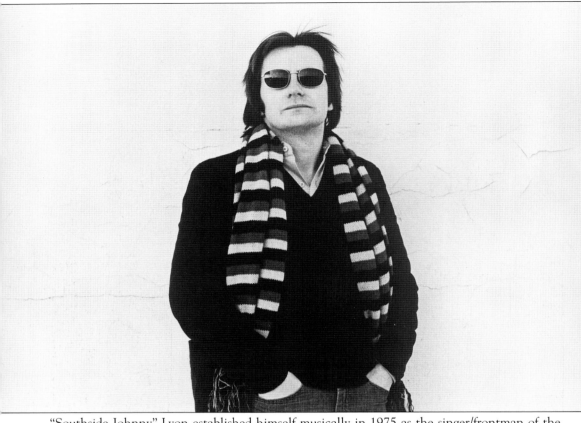

"Southside Johnny" Lyon established himself musically in 1975 as the singer/frontman of the famous "Asbury Jukes." Lyons' 1967 Neptune High School yearbook notes his love for blues and rock and his dislike for madras (the "Establishment" fashion keynote in the mid-1960s). In February of 1990, Lyons disbanded his working band of 15 years—bass player George Ruiz, drummer Tommy Major, keyboard man Wes Nagy, trumpeter Barry Danellian, sax player Joey Stann, and trombonist Stan Levine—in favor of a "newer sound." The only musician to stay with Lyons was singer/guitarist Bobby Bandiera. The reinvented "Jukes" still tour—and delight Shore area fans—with Neptune's own Southside Johnny's groove. (Photo by David Gahr.)

Eleven

SHARK RIVER HILLS

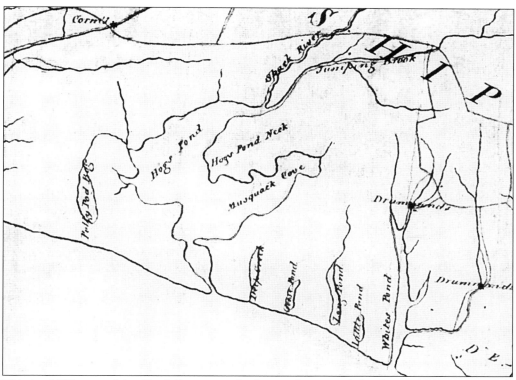

This is a 1781 map of the Shark River area. In this rendering made by General Clinton's British forces during the Revolutionary War, lower Shark River appears as "Hogs Pond" named for the many shoat (pig) farms along its banks. Shark River Hills appears as "Hog Pond Neck." "Musquash Cove," a Lenape name meaning "muskrat" retains its name even today. A British raiding party was routed when it attacked local saltworks on the south side of Hogs Pond in April 1778. Salt distilled from seawater was indispensable for preserving food before refrigeration, and, more importantly for American independence, was a necessary ingredient in the manufacture of gunpowder. (Monmouth County Archives.)

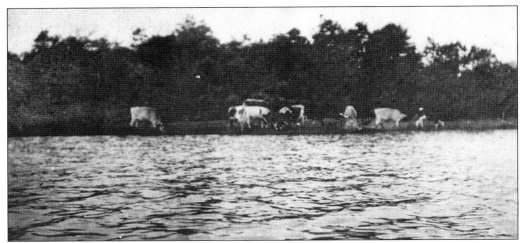

Shown here is County Neck, Shark River Hills, about 1907. In 1767 the Shark River Hills property was surveyed for sale to David and Peter Knott, who never occupied the land. In 1801 it was sold for use as the County Poor Farm. The Alms House earned money by allowing local farmers to graze cattle along the river, as seen here. The river was essential to the local economy—people leased shellfish beds, fished commercially, and built boats there. When Henry Yard tried to buy the land beneath Shark River in 1881, residents appealed to the State to protect their rights to use the river. The State of New Jersey agreed that rivers and the lands washed by them should remain public domain, and riparian law as we know it was set by this Shark River case. (Neptune Historical Museum.)

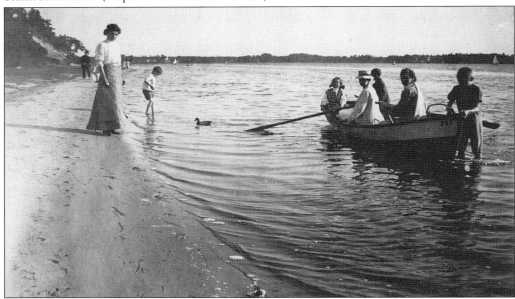

In this view of Long Point, taken in 1909, a crew of ladies man the oars of the rowboat while a boy and duck enjoy the shallows. A wagon path leading from the Poor Farm to Long Point allowed wagon access for locals on their way to picnic, clam, or fish at the point of this broad peninsula known as County Neck. New Jersey's Lenape Indians called the Shark River "Nollequesett" and the Hills area "Pequodlenoyack." The Lenape had relinquished their homeland to European buyers beginning in the late 1600s. (Neptune Historical Museum.)

The last meeting of Alms House directors in June 1916 ended 115 years of existence for Shark River Hills' County Poor Farm. Pictured from left to right are: (seated) D.W. Vannote of Belford (Middletown Township), Mrs. Cyrus Low (steward), Cyrus Low (overseer), Gertrude Low, and Charles White of Wall (commissioner, Wall Township); (back row) Harry Lecompte of Point Pleasant (commissioner, Brick Township), Aaron Sutphen of Colts Neck (commissioner, Atlantic Township), Robert Morris of Adelphia (commissioner, Howell Township), Joseph Nevis of Adelphia, and W. Scott Jackson of Toms River (commissioner, Dover Township). (Asbury Park Press.)

With the county Poor Farm only a memory after WW I, a flier named Lieutenant Stuart A. Morgan turned the property into the Asbury Park Aviation Field. He taught flying, made regular passenger flights, and gave exhibitions of daring stunt flying in old army planes. A newspaper advertisement shows one of Lt. Morgan's biplanes soaring above what is now the Shark River Golf Course. A plan to utilize the Hills for shooting early silent films—unlike Lt. Morgan's biplanes—didn't ever quite make it off the ground. (Neptune Historical Museum Archives).

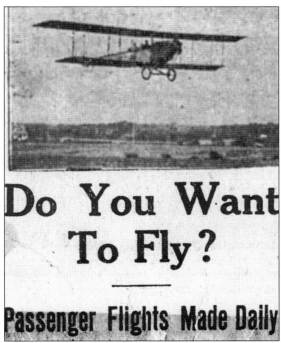

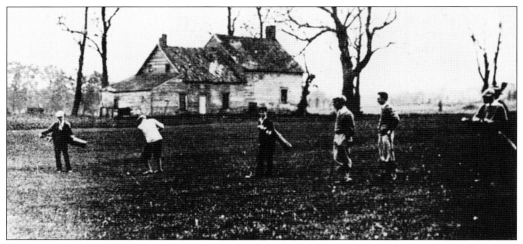

Golfers play through in front of the Alms House off Old Corlies Avenue about 1914. Needing a location to house indigents in 1801, the Monmouth County Freeholders purchased from William Parker some 700 acres to serve poor persons from 11 townships. The 50-by-34-foot building housed all ages, races, and levels of mental stability. Residents raised cows, pigs, and chickens, and sold produce and eggs. A potters field, graves unmarked, offered final shelter there. The building was torn down in 1915 and the land became the Asbury Park Golf and Country Club, now the Shark River Golf Course. In 1919 the Shark River Hills Company sold part of the land that had been the County Poor Farm to the city of Asbury Park. The sale helped finance development of Shark River Hills into a resort. The year 1920 saw the formal opening of the 18-hole, 6,300-yard Asbury Park Golf and Country Club course, dedicated to WW I heroes. (Courtesy Helen Pike.)

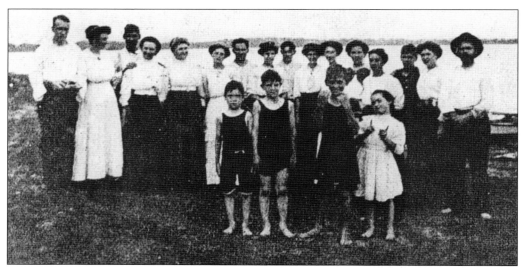

Long Point, seen here c. 1910, was always a favorite spot for picnics and clambakes. A group of local couples and their families appear to have enjoyed themselves on just such an occasion in this photograph. The players in this beach scene would be familiar today: adults sated from good food and talk, and sunburned kids in salty and still-damp swimming clothes. Everyone goes home tired and happy. Our little girl's thumbs up-type gesture says it all for such magic afternoons. (Neptune Historical Museum.)

Were these girls really crabbing or did they simply strike a pose that afternoon in 1908? Either way, the occasion provided a charming glimpse of female casual deportment amidst the tyranny of bows and corsets. (Neptune Historical Museum.)

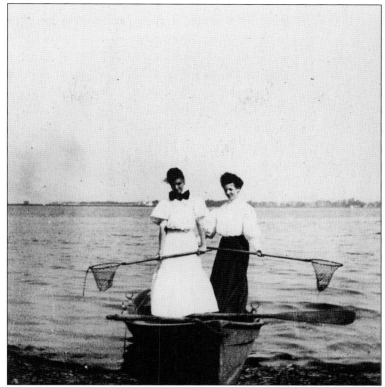

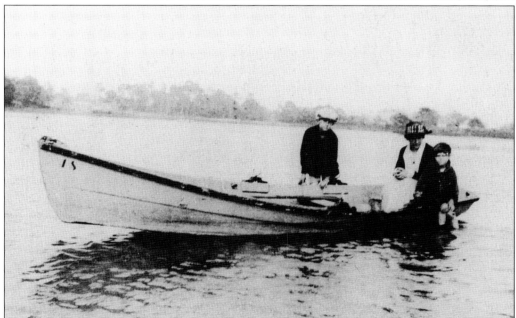

Little boys under the watchful eye of a matron enjoy a day out on the river about 1907. Given women's over-dressing of the era, the question arises: Who would save whom if the boat turned over? (Neptune Historical Museum.)

The oldest house in Shark River Hills, this little bungalow saw it all. Built in 1913, the house was owned by the Hills real estate legend Virginia Updegraff and her daughter Virginia Tonietti. It often appeared in early advertisements for Shark River Hills. The house is seen in 1924, before a garage was added. It has since been relocated from this setting at 645 South Riverside Drive to its present location on Glenmere Avenue. (Courtesy Jimmy Magill.)

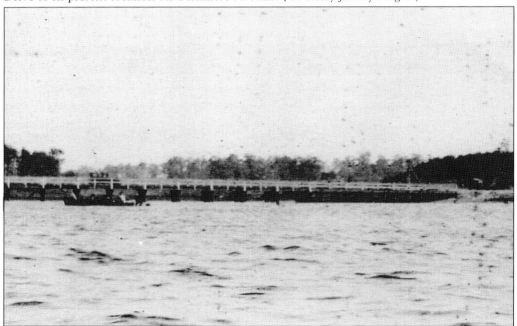

Spanning the waters of Shark River in 1924 is Tucker's Point Bridge, linking Shark River Hills to Neptune City. Built in August of 1923 at a cost of $35,000, the bridge provided a vital access route into the Hills and did much to speed the area's development. The "music" of the bridge as traffic traversed its wooden deck was a familiar feature, especially on quiet nights in the Hills. (Neptune Historical Museum.)

James D. Carton, founder of the Shark River Hills Company (left) and his son, Victor Carton, take in the view on horseback from Skytop about 1924. Also known as "Money Hill," Skytop was rumored to be the place of Captain Kidd's pirate treasure. This natural prominence, at 118 feet the second-highest point along the Jersey Coast Skytop, offers a panoramic view of Asbury Park, Ocean Grove, Spring Lake, and the Atlantic Ocean. Could the Cartons have visualized the more than 1,700 houses that would fill that same landscape in the coming years? (Courtesy Jean-Marie Predham.)

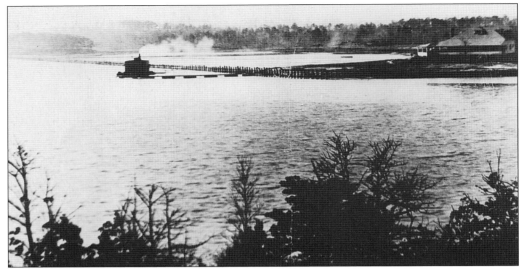

A dredge (left) scoops out channel sand which will fill in the cove facing the Shark River Hills Country Club (right). From 1922 to 1928 the dredge worked tirelessly, evening out the irregular natural coastline along Riverside Drive, and dredging sand from offshore, which was deposited along the waters edge to add suitable development acreage where wetlands had existed. In the process, three offshore islands were destroyed, but the outline of Shark River Hills as we know it was defined. (Courtesy Mary Holihan.)

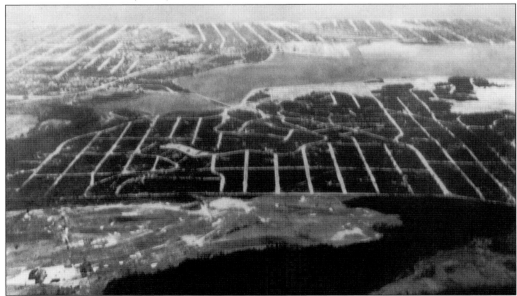

An early 1920s aerial view displays a grid of sandy roads that would soon become the streets of Shark River Hills. Streets were named for members of the original Shark River Hills Company board of directors and their family members. Wilson Road was the first route to be cut through the laurel and pines. The year 1923 saw the Shark River Hills Company expending $49,343 for its streets project, and that year alone over 6 miles of hard-surface road appeared in the Hills. Newly finished Tucker's Point Bridge may be seen crossing Musquash Cove to the left. (Neptune Historical Museum.)

The "Shark River Hills Girl" was a creation of the Morrisey and Walker Company, which promoted Shark River Hills. She appeared in many forms, her swimsuit style being modified with the changing times, to enhance brochures, newspaper ads, and billboards for Hills promotions. Road signs were a clever advertising ploy geared to the growing popularity of motorcar travel, with our bathing beauty beckoning "Meet Me in Shark River Hills" to drivers about 1924. (Neptune Historical Museum.)

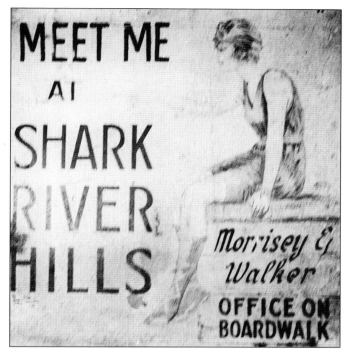

Here is Opportunity!

Tomorrow is the Last Day of

OPENING WEEK

Hotel Section No. 1

SUPPOSE you could have bought land immediately adjoining the new Berkeley-Carteret Hotel, the Monterey Hotel or any of the many modern hotels in Asbury Park, or the Hotel Marlboro-Blenheim in Atlantic City — BEFORE these hotels were built, at low prices and on easy monthly terms? Can you picture the immense PROFITS you would have made! That picture seems almost too good for your imagination, doesn't it? Yet here at

The first Hills section offered for sale by Morrisey and Walker was north of Overlook Drive from Musquash Brook to Brighton Avenue, and opened in July of 1923. Other segments opened up in 1924. This piece of publicity hyped "Hotel Section No. 1," underscoring the desirability of Hills ownership by borrowing a little prestige from the grandeur of nearby Asbury Park. An image of the thriving Berkeley-Carteret Hotel suggests how much money savvy real estate investors could make by buying into a developing area early and "getting in on the ground floor." Confident Morrisey and Walker agents offered to buy back any property sold that week at 100 percent profit. (Neptune Historical Museum.)

CONTRACT FOR PROPERTY

Shark River Hills Co.

(Body Corporate)

By Morrisey & Walker, Inc.

(Authorized Agent)

TO

Vera D. Taintor

Dated August 3, 1925

Lots Nos. 19-20 Block 10

Section A

Price $820

Vera D. Taintor signed this Morrisey and Walker contract for a lot in Shark River Hills in 1925. Customers had little resistance to buying a piece of what was advertised as "600 rolling tree-covered acres with 3 1/2 miles of waterfront." The cost of a lot was minimal, from $85 to $500, and terms were always "reasonable." (Neptune Historical Museum.)

Prospective land purchasers would receive *The Bungalow Book*, distributed by Morrisey And Walker. It contained 20 different bungalow models built by the company, which billed itself as "the largest builders on the Jersey Coast," and touted quality construction at low cost. A Morrisey and Walker payment plan was available "to accommodate nearly everybody's circumstances." (Neptune Historical Museum.)

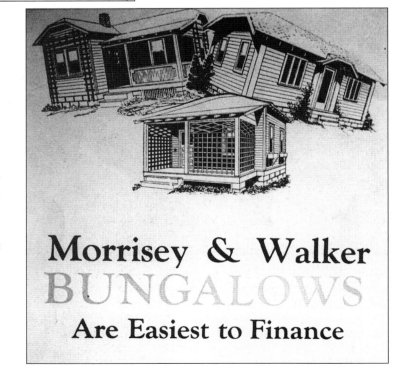

Morrisey & Walker
BUNGALOWS
Are Easiest to Finance

100

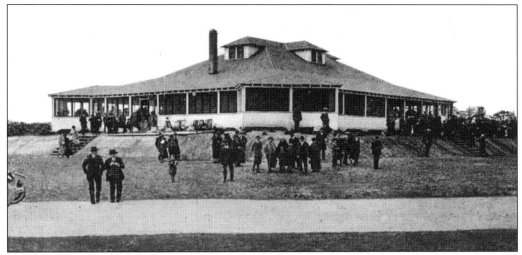

The Shark River Hills Country Clubhouse is pictured atop its knoll in 1928. Built in 1924 on what was then a small island near Tucker's Point Bridge, the club became the focal point for community activities. In addition to its swimming and diving pier, fishing pier, and boat landing, its clubhouse offered breezy verandas for enjoying the out-of-doors. If there was one hub around which everything in the Shark River Hills community revolved, it was the Shark River Hills Country Club. A full range of social activities there included dances, whist parties, teas, tennis, and deck games. Mrs. W.T. Tomlin, organizer of the Shark River Hills Property Owners Association, reigned as the official club hostess. The Country Club enjoyed continued activity through the 1960s, when a fire destroyed the building. (Neptune Historical Museum.)

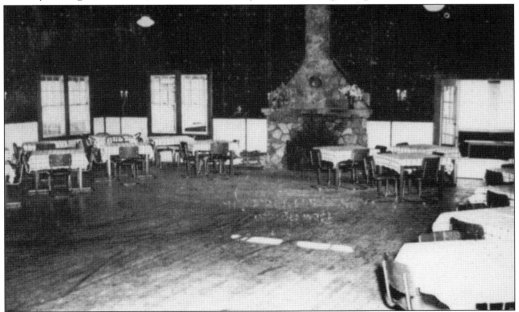

The Country Club interior is shown here. Inside, a dance floor and ample fireplace lent ambiance to the dining area. The chowder parties, masquerades, corn roasts, musicales, card parties, and dances brought Hills residents together and made for a tightly knit community. (Neptune Historic Museum.)

.. Halloween Dance ..

Shark River Hills Country Club
SATURDAY, OCTOBER 28, 1950
at 8.30 P. M.
Music by Eddie Smith

Guests $1.20 Members 60c

A 1950 Halloween dance ticket for the Shark River Hills Country Club is shown here. Holidays were excellent occasions to stage get-togethers at the club. Eddie Smith's band was one of many which provided musical entertainment for the guests. (Neptune Historical Museum.)

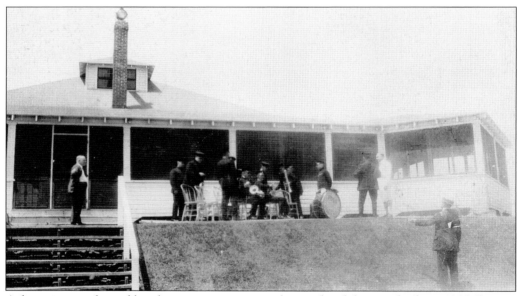

A five-piece uniformed band is seen setting up to play on the club veranda about 1930. Dances and nightly music-filled evenings were standard popular fare at the Country Club. Many bands entertained over the years there, including Adolph Snyder and his Orchestra, Jay Edwards and the Musicians, and Eddie Smith. The only identification for this group is some lettering on the bass drum, reading "VOSS" and "Belmar, NJ." (Neptune Historical Museum.)

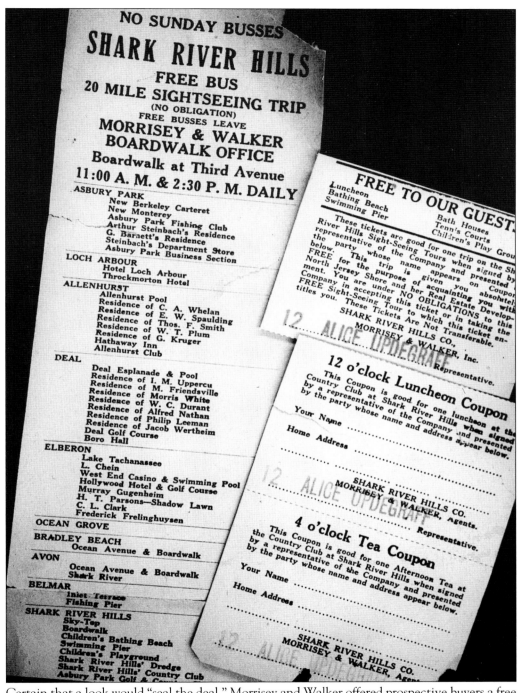

NO SUNDAY BUSSES

SHARK RIVER HILLS

FREE BUS
20 MILE SIGHTSEEING TRIP
(NO OBLIGATION)
FREE BUSSES LEAVE

MORRISEY & WALKER
BOARDWALK OFFICE
Boardwalk at Third Avenue
11:00 A. M. & 2:30 P. M. DAILY

ASBURY PARK
New Berkeley Carteret
New Monterey
Asbury Park Fishing Club
Arthur Steinbach's Residence
G. Barnett's Residence
Steinbach's Department Store
Asbury Park Business Section

LOCH ARBOUR
Hotel Loch Arbour
Throckmorton Hotel

ALLENHURST
Allenhurst Pool
Residence of C. A. Whelan
Residence of E. W. Spaulding
Residence of Thos. F. Smith
Residence of W. T. Plum
Residence of G. Kruger
Hathaway Inn
Allenhurst Club

DEAL
Deal Esplanade & Pool
Residence of I. M. Uppercu
Residence of M. Friendsville
Residence of Morris White
Residence of W. C. Durant
Residence of Alfred Nathan
Residence of Philip Leeman
Residence of Jacob Wertheim
Deal Golf Course
Boro Hall

ELBERON
Lake Tachanassee
L. Chein
West End Casino & Swimming Pool
Hollywood Hotel & Golf Course
Murray Gugenheim
H. T. Parsons—Shadow Lawn
C. L. Clark
Frederick Frelinghuysen

OCEAN GROVE

BRADLEY BEACH
Ocean Avenue & Boardwalk

AVON
Ocean Avenue & Boardwalk
Shark River

BELMAR
Inlet Terrace
Fishing Pier

SHARK RIVER HILLS
Sky-Top
Boardwalk
Children's Bathing Beach
Swimming Pier
Children's Playground
Shark River Hills' Dredge
Shark River Hills' Country Club
Asbury Park Golf & Co

FREE TO OUR GUEST
Luncheon
Bathing Beach
Swimming Pier
Bath Houses
Tenn's Courts
Children's Play Grou

These tickets are good for one trip on the Sh
River Hills Sight-Seeing Tours when signed by
representative of the Company and presented
the party whose name appears on Coupon
below. This trip is given you absolutel
FREE for the purpose of acquainting you with
North Jersey Shore and her Real Estate Develop-
ment. You are under NO OBLIGATIONS to this
Company in accepting this ticket or in taking the
FREE Sight-Seeing Tour to which this ticket en-
titles you. These Tickets Are Not Transferable.

SHARK RIVER HILLS CO.,
MORRISEY & WALKER, Inc.
Representative.

12 *ALICE UPDEGRAFF*

12 o'clock Luncheon Coupon
This Coupon is good for one luncheon at the
Country Club at Shark River Hills when signed
by a representative of the Company and presented
by the party whose name and address appear below.

Your Name

Home Address

SHARK RIVER HILLS CO.
MORRISEY & WALKER, Agents.

12 *ALICE UPDEGRAFF*

Representative.

4 o'clock Tea Coupon
This Coupon is good for one Afternoon Tea at
the Country Club at Shark River Hills when signed
by a representative of the Company and presented
by the party whose name and address appear below.

Your Name

Home Address

SHARK RIVER HILLS CO.
MORRISEY & WALKER, Ager

12 *ALICE UPDEGRAFF*

Certain that a look would "seal the deal," Morrisey and Walker offered prospective buyers a free 20-mile bus ride through Asbury Park, Loch Arbor, Allenhurst, Deal, Elberon, Ocean Grove, and Bradley Beach, winding up at Shark River Hills. Packard buses left from Morrisey and Walker's Asbury boardwalk offices twice daily, and riders' tickets contained vouchers for a free lunch or tea at the new Shark River Hills Country Club. (Neptune Historical Museum.)

The boardwalk and dock at Shark River Hills led to water fun and river vistas. The boardwalk ran from Tucker's Point Bridge to the Country Club area here, then southward to the Shark River Hills Hotel. Over the years, storms badly damaged the walkway. Its death blow arrived with the great hurricane of 1944. (Neptune Historical Museum.)

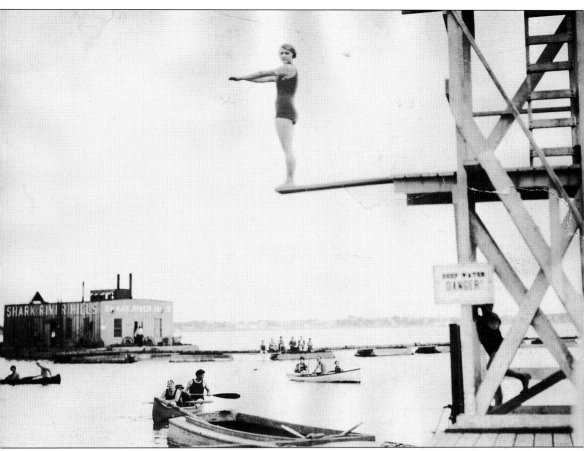

The Hills' diving board and dive tower were state of the art in 1925. Dive contests drew competitors from YMCAs across the state as well as from out-of-state sports bastions such as the New York Athletic Club. Competitions for diving and swimming saw several world records set in Shark River Hills.(Neptune Historical Museum.)

Crowds line the boardwalk to watch the exciting water sports competitions. In 1925, competing athletes included Gertrude Edderly, Walter Spence (world's record, 300-meter swim), Robert Hosie (world's record, 1-mile junior metropolitan backstroke), and Agnes Geraghty (long course record time for 220-yard breaststroke). (Neptune Historical Museum.)

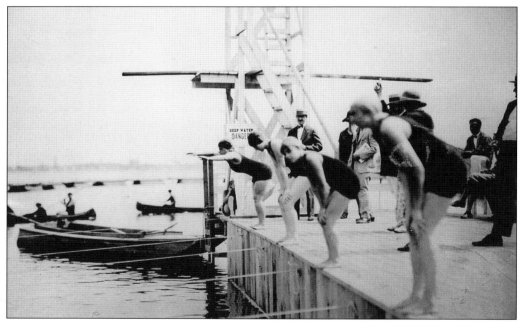

The starting gun signals a swimmer's start at a competition c. 1930. One well-attended specialty at the Country Club was an event for local residents known as the "Sharkerina." Participants dove off the dock, swam 100 feet to a raft, struggled into ladies' dresses, stockings, and bonnets on the raft, and swam back (carrying an umbrella) to the starting point. With umbrella open and stockings properly rolled above the knees, the first one to land on the dock claimed victory. (Neptune Historical Museum.)

WATER CARNIVAL .

TO BE HELD AT THE

Shark River Hills Country Club

JULY 4, 1925
3:30 P. M.

ROWING (MEN)
SINGLE

	1st Heat	2nd Heat	3rd Heat
RED	—Gordon Lish Trenton	C. V. Dennis Newark	E. Singer El Mora
WHITE	—William Heiceling Irvington	Otto Heiceling Irvington	B. Klaentel
BLUE	—F. S. Ford Bellville	R. C. Hallis Newark	E. Heinceling Irvington
GREEN	—C. H. Kraenter	R. Singer El Mora	F. Heinceling Irvington

FINAL
SINGLES WITH PASSENGER

RED —F. S. Ford, Bellville
BLUE —R. C. Harris, Newark

DOUBLE SCULL (MALE)

RED —Ray de Nouri, Bloomfield
RED —Bruce de Nouri, Bloomfield
GREEN—E. Singer, El Mora
GREEN—R. Singer, El Mora

ROWING (LADIES)
SINGLES

	1st Heat		2nd Heat
RED	—Alice Fruenal Hoboken	GREEN	—May Hayes Jersey City
WHITE	—A. Harvey Brooklyn	YELLOW	—Minnie Fruenel Hoboken
BLUE	—Lyda Gardener Bayonne	BROWN	—Olga Harvey Brooklyn

FINAL
CANOE TILTING

A Water Carnival program from 1925 promises fun and excitement. Included is a tub race and the "Gymkana." Gymkana entrants began with a run, then a 100-foot bag hop to a bicycle race, followed by a swim to a boat. Next they were required to light a pipe, sit in the stern, hoist anchor, and paddle back to the dock. As if that weren't enough, the winner was expected to run back to the starting point and arrive first—with pipe alight—at the finish line. (Neptune Historical Museum.)

The courts: Tennis anyone? "Fast, well-kept tennis courts are always available," promises a Shark River Hills Company official advertising brochure in 1935. Apparently fashion statements were pretty hot too, with our stylishly attired players the very picture of 1920s courtside chic. (Neptune Historical Museum.)

This 1924 photograph demonstrates two facts: (a) swing sets never lose their appeal with the young; (b) neither does the "boys on one side/girls on the other side" gender division. Lumber stacked in the background suggests the boardwalk which ran from Tucker's Bridge to the Country Club was in the process of being constructed at the time this photograph was taken. (Neptune Historical Museum.)

In this playground scene of 1924, children interrupt a trip down the slide to pose for the camera. Family life and recreation drove development in Shark River Hills. Morrisey and Walker devoted much effort and money towards providing extensive play facilities for children. (Neptune Historical Museum.)

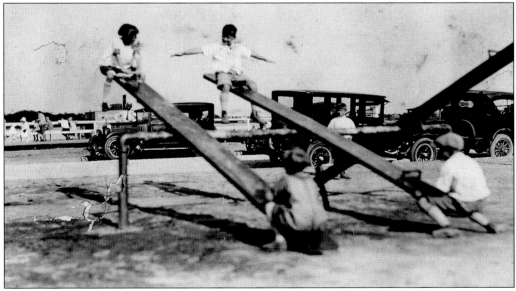

A lad tests his balance mid-air on a playground seesaw in this pre-1930 photograph. Vintage automobiles seen in the background brought the cloche-hatted ladies and straw-skimmered gentleman who came to watch the river sights from waterside benches. (Neptune Historical Museum.)

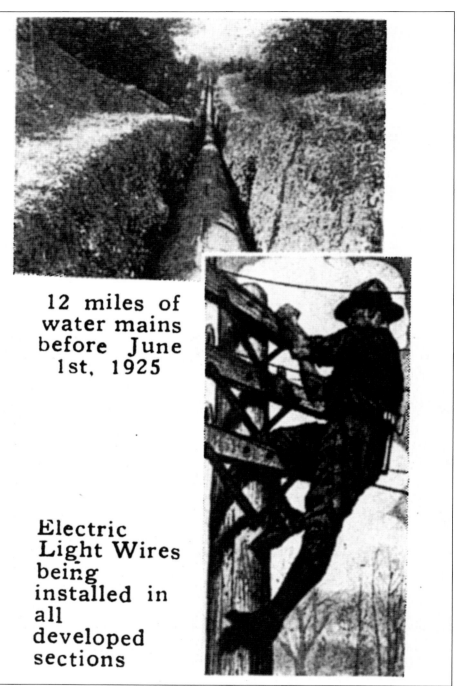

12 miles of
water mains
before June
1st, 1925

Electric
Light Wires
being
installed in
all
developed
sections

A 1924 advertising brochure proclaims $500,000 to be appropriated for Shark River Hills improvements in the coming year. The Shark River Hills Company kept the buying public apprised of each improvement added to their riverside development. These included plans for bulkheading, dredging, water mains, electric service, a bathing beach, a community center, and a new road to be called Riverside Drive. (Neptune Historical Museum.)

110

In 1936 the Shark River Property Owners Association advertised for members via this application form published in the *Shark River Hills Times*. The SHRPOA organized in 1929 with the purpose of promoting the quality of life in Shark River Hills and Neptune. Today the organization has over 500 members and serves its community in many capacities, from providing public forums on local issues, to beautifying the neighborhood with flower plantings, to providing the signs that welcome visitors to Shark River Hills. (Neptune Historical Museum.)

Application for Membership

Shark River Hills Property Owners' Assn.
Shark River Hills, New Jersey

Name ...

Home Address ...

Shark River Hills Address ...

Do You Intend to Build ...

If So, When ..

MEMBERSHIP FEE: ONE DOLLAR A YEAR

"That funny little house" which stands at the corner of Riverview Court at Riverside Drive was once the sales office of the Shark River Hills Company. The *Shark River Hills Times* announced the switching of business operations from the 320 Cookman Avenue office to this new on-site office beginning May 1, 1928. Salesmen relaxing in rocking chairs provided an advertisement for the Hills' easy living as they waited for prospective customers on the office porch. (Neptune Historical Museum.)

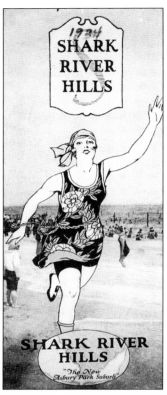

"The Shark River Hills Girl," in her 1934 incarnation, advertises the Hills as "The New Asbury Park Suburb." Printed in shades of green and orange, she fairly bursts from the black-and-white brochure background. Inside pages picture happy bathers, a model house, playground attractions, and crowds of customers at Morrisey and Walker's Asbury Park sales office. This brochure retains the hand-written name of the salesman who handed it out over 70 years ago, "E. Bowlby." (Neptune Historical Museum.)

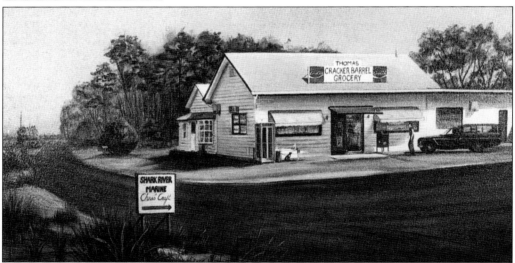

The Cracker Barrel has been a local landmark at the foot of Tucker's Bridge since 1925, when Henry and Mary Dolan opened a store in their home there. One could buy groceries, auto parts, or gasoline, enjoy ice cream on their porch, or rent boats. Bus service around the Hills left from the store. The Cracker Barrel passed to the Daum's in 1933, and was enlarged under Harry Robinson and Ed Parker. The store took the name "Cracker Barrel" in 1951, when Mr. and Mrs. Blauvelt took it over. The store has expanded multiple times and has prospered under a sequence of owners. (Neptune Historical Museum.)

Sec. 435½ P. L. &

1c Paid
Asbury Park, N.
Permit No. 17

Shark River Hills Times

VOL. IV., No. 21 SHARK RIVER HILLS, N. J., JULY 10, 1930 FIVE CENTS PER CO

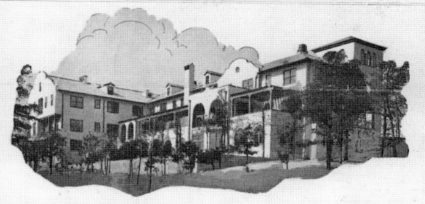

SHARK RIVER HILLS IDEAL FOR CHILDRE

Air, Surroundings and Facilities f Healthful, Enjoyable Play Give Them Their Big Chance

THEY'RE ALL HAPPY

These are the days when the ch dren of the families lving in Sha River Hills get the cream of the fu "Ain't we got fun!"

See-saws, swings, wading, fishing—nothing has been forgotten that wou contribute to enjoyment of summ by the kiddies. Oh, it would warm th cockles of your hard old heart to he the merry laughter of these little on as they romp and frolic, free fro cares of traffic, enjoying the bene cent air, swept by breezes from ocea river and bay.

Here the children enjoy the thing that great and loving Creator i tended they should have. Oh, we a proud of our children! And we a proud that we have been instrument in providing these real opportuniti for those children. It is a privileg a wonderful privilege to be able give these advantages to the litt ones. They have a right to suc things, but, alas! all too often w wait until too late to give them th chance to grow up into strong an healthy manhood and womanhood.

We enable them here in Shar River Mills to breathe pure air i the glorious surroundings of green clad hills, woods and beautiful blu

S. R. H. Hotel Gets Bang-Up Start Successful Season Now Certain

Innovations of Mr. Graham and Large Number of Reservations Prove Popularity of Our Beautiful Hostelry; Inquiries From All Over the East.

HERE ARE RATES

The biggest year in the history of Shark River Hills!

That was the prediction made on all sides as our beautiful new hotel got under way for the season, with every prospect for a bang-up year from every viewpoint as scores of reservations were received by Mr. Graham and hundreds of inquiries were answered by him.

With new attractiveness, an un-matched cuisine and service, and with a man in charge who knows his busi-ness from A to Z, the stage is set for a new record in hotel patronage on the North Jersey shore. The natural

Among those who have made reser-vations are the following:

Judge and Mrs. W. E. Tompkins, New York City.

Mr. and Mrs. David Walsh, Boston, Mass.

$2.50. Music will be furnished during dinner and for dancing after dinner by Les Smith and his Shark River Hills Hotel Orchestra, who during the past winter have been broadcasting over station WOR. Many small din-ner parties have been booked for this room.

REFRESHMENTS AT CLUB HOUSE

Mr. and Mrs. R. E. Tucker have taken over the conncession at the Club House, which will be open every day from 9 A. M. to 12 P. M. for the sale of candy, cigars, ice cream and soft drinks. They will also have for sale clam chowder, sandwiches and coffee. We hope the people of Shark River Hills will remember them and that they will patronize the Club House. This is done for the accommodation of property owners of Shark River Hills

The first edition of the *Shark River Hills Times* appeared in August 1928. Mr. William J. Tomlin was the publisher and first editor, and the four-page weekly was originally distributed to all Hills property owners at a penny each. The *Times* carried news and happenings in the Hills, keeping residents up to date about their Hills community. The familiar *Country Club Edition* was published through 1933, then took a hiatus, only to return for a few last issues in 1939. (Neptune Historical Museum.)

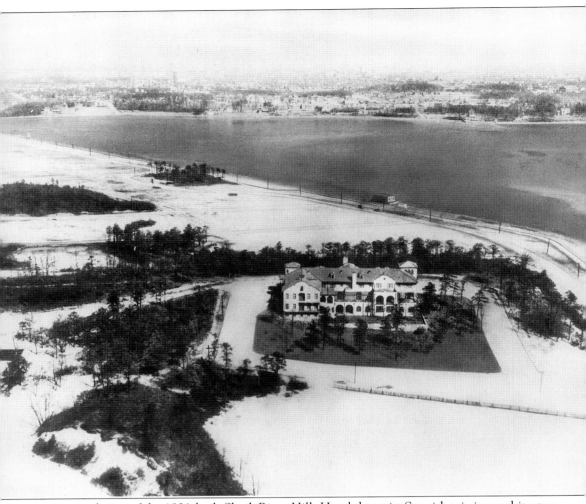

An aerial view of the 1931-built Shark River Hills Hotel shows its Spanish mission architecture and picture-perfect setting on South Riverside Drive. The hotel featured rich wall tapestries and oriental rugs, plus its own orchestra. Its Spanish Grill turned out steaks and seafood for luncheons, dinners, and organizational bookings. Despite its quality and location, the hotel never lived up to its commercial promise. It was occupied by the Army during WW II, then operated as the Riverview Christian Academy from 1952 to the mid-1970s. It has since been demolished. (Neptune Historical Museum.)

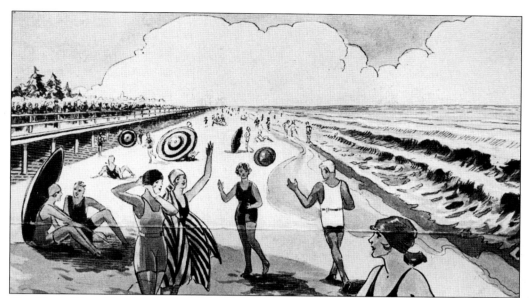

The Shark River Beach is shown here, albeit as a product of artistic license. Rolling breakers like these belong more to the Atlantic than to the river beach. Still, the artist who designed this 1930s advertising piece succeeded in rendering an inviting bathing scene of beach and boardwalk that would tempt anyone to look at property in Shark River Hills. (Neptune Historical Museum.)

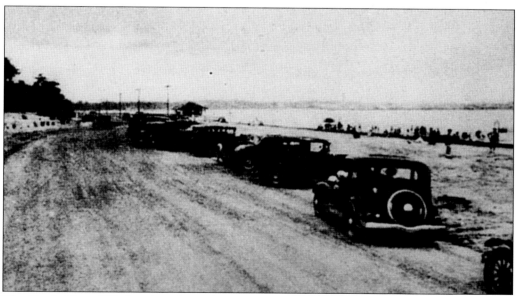

The Shark River Hills beach is shown here as it actually appeared in 1932. No breakers are in sight, just a tide of wonderful old-time automobiles. In 1947, Shark River Hills homeowners pledged money to purchase the former Shark River Hills Hotel beach for their members' exclusive use. In 1952, the purchase was consummated and the land became the official property of the Shark River Hills Beach Corporation. (Neptune Historical Museum.)

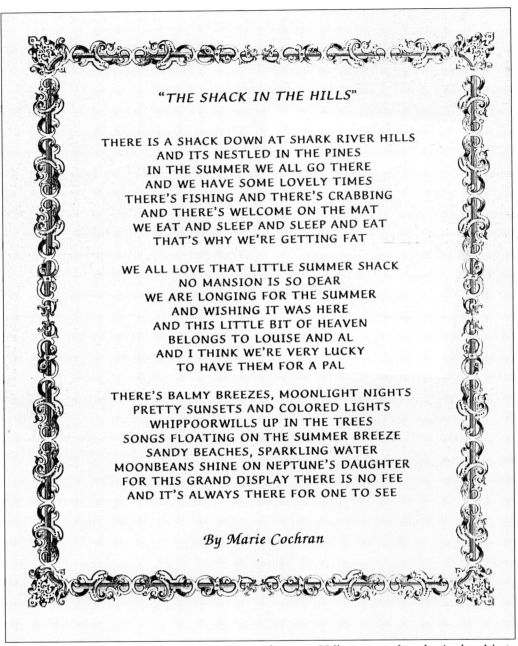

"THE SHACK IN THE HILLS"

THERE IS A SHACK DOWN AT SHARK RIVER HILLS
AND ITS NESTLED IN THE PINES
IN THE SUMMER WE ALL GO THERE
AND WE HAVE SOME LOVELY TIMES
THERE'S FISHING AND THERE'S CRABBING
AND THERE'S WELCOME ON THE MAT
WE EAT AND SLEEP AND SLEEP AND EAT
THAT'S WHY WE'RE GETTING FAT

WE ALL LOVE THAT LITTLE SUMMER SHACK
NO MANSION IS SO DEAR
WE ARE LONGING FOR THE SUMMER
AND WISHING IT WAS HERE
AND THIS LITTLE BIT OF HEAVEN
BELONGS TO LOUISE AND AL
AND I THINK WE'RE VERY LUCKY
TO HAVE THEM FOR A PAL

THERE'S BALMY BREEZES, MOONLIGHT NIGHTS
PRETTY SUNSETS AND COLORED LIGHTS
WHIPPOORWILLS UP IN THE TREES
SONGS FLOATING ON THE SUMMER BREEZE
SANDY BEACHES, SPARKLING WATER
MOONBEANS SHINE ON NEPTUNE'S DAUGHTER
FOR THIS GRAND DISPLAY THERE IS NO FEE
AND IT'S ALWAYS THERE FOR ONE TO SEE

By Marie Cochran

This original poem appeared as a Christmas card sent to Hills summer friends. Author Marie Cochran penned the verses around 1935. (Neptune Historical Museum.)

As naturally idyllic as the resort seemed in summer, the Hills in winter held special charm. "The Snows Came," a 1937 image by photographer Bill Walworth, captured the beauty of a snow landscape on Schock Avenue. The street's namesake was the owner of the Spring Lake Hotel. (Neptune Historical Museum.)

The Community Baptist Chapel began as an interdenominational group of worshippers who first met in 1942 at the Shark River Hills Firehouse. In 1943 they moved to a private home on Lakewood Drive, with Rev. John Fitzpatrick as their first minister. The organ was donated by William J. Couse, a member of the Shark River Hills Company's Board of Directors. A new edifice was built in 1960, with a steeple added in 1962. Vacation Bible School there is a fond memory for many. In 1963 church members voted to change the name to the Community Baptist Chapel. (Personal photo.)

WOULD YOU BELIEVE IT?

A Six Room Cottage, stone fireplace, two-car garage

Well situated on two lots, corner property. Furnished

ALL FOR $2500

See Company Office on Property

Shark River Hills, N. J.

A 1930s "Property For Sale" advertisement in the *Shark River Hills Times* offers a lot for your money. How quickly we all would respond today to such a bargain price! (Neptune Historical Museum.)

Mrs. Alice V. Updegraff, real estate saleswoman extraordinaire, introduced many eventual purchasers to the beauty and amenities of Shark River Hills. Mrs. Updegraff commuted each day from her home in Matawan to her job as agent for the Morrisey and Walker Company. In 1924 she took her own sales pitch to heart and purchased the first home built in the Hills. (Neptune Historical Museum.)

Smiles—not champagne—christen a new rowboat in 1943. Seated in the boat are Betsy and Jimmy Magill. Standing far left is Virginia Tonietti. Virginia inherited her mother's penchant for real estate sales. She eventually took over the family business. Others identified in the photo are George Magill (third from left), Catherine Springhorn (fourth from left), and Margaret Magill (extreme right in back row). Bending at the prow is Catherine Springhorn's sister. (Courtesy Ann McCall.)

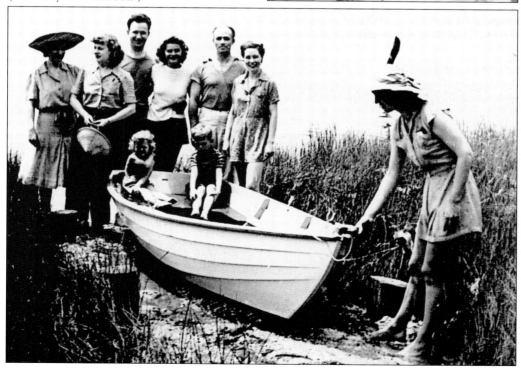

SHARK RIVER HILLS
SILVER JUBILEE
1924 -- 1949

The residents of Shark River Hills will be celebrating their Silver Jubilee over the week-end of July 2, 3, 4 and they are inviting their neighbors of the surrounding communities to share in the activities.

A few of the events are listed below:

MOTOR BOAT RACES

SOAP BOX DERBY --- 10 A.M. July 4th

BATHING BEAUTY CONTEST

SOFT BALL GAMES

DINNER and DANCE at the Club House

MEMORIAL SERVICE in the Community Chapel
 on Lakewood Road

OPEN HOUSE at the Club House all day July 4th.
Fireworks at night

Entry blanks and dates for contests will be published in the Asbury Park Press.

For further information call the chairman:

Roy Trudel Asbury Park 2-5475

Shark River Hills did it up right for its 25-year anniversary in 1949. This handbill advertises just a few of the many events scheduled for the weekend of July 2, 3, and 4 in the year of Silver Jubilee. (Neptune Historical Museum.)

The American Legion-sponsored Soap Box Derby was a classic competition for youngsters in the Hills. Here's the very first coaster derby, finishing on South Riverside Drive on July 4, 1949, the year of Shark River Hills' Silver Jubilee. Our proud winner is seen receiving his trophy from Mr. Roy Trudel, then president of the Shark River Hills Property Owners Association. (Neptune Historical Museum.)

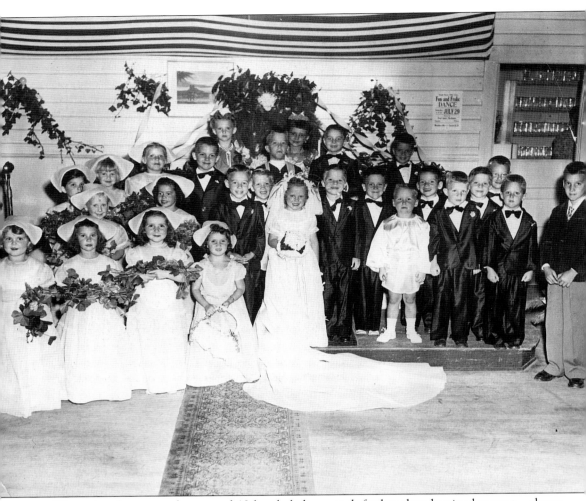

Fifteen handsome gentlemen and 12 lovely ladies—each fresher than her ivy bouquet—charm viewers from this Tom Thumb wedding picture taken at the Shark River Hills Country Club in 1950. Unfortunately, no identification was available with the photograph to document just who married whom and whether "it all worked out" for the happy couple, who by now would be nearing their golden wedding anniversary. (Neptune Historical Museum Archives.)

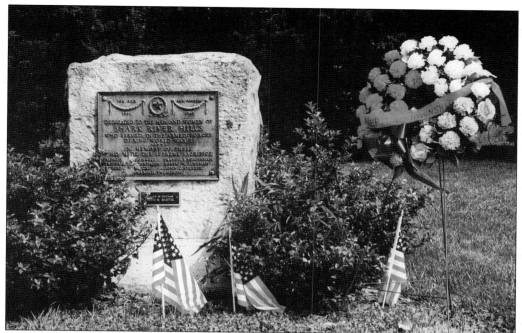

Sponsored by the Shark River Hills Homeowners Association, Memorial Park was dedicated on May 30, 1950. The monument commemorates the Hills' sons who died in WW II: Alfred Antonucci, Frederick Frommhagen, Robert Henricks, Francis Hergenahn, Robert Linehan, John O'Keefe, and Harold Thompson. (Personal photo.)

In 1971 incorporation papers were drawn up merging the Shark River Beach Club with the Shark River Yacht Club. Lobster roasts, boat races, and the like, plus a yacht club newspaper offered Hills residents a new entertainment mecca right at home. (Personal photo.)

The Shark River Hills Company sold its holdings in 1953 to brothers William and Everett Oliver, and the new owners focused on building Cape Cod and Ranch-style houses for middle-income, year-round buyers under the name Shark River Hills Estates. The Olivers increased population numbers in the Hills quickly by erecting some 50 homes each year. (Neptune Historical Museum.)

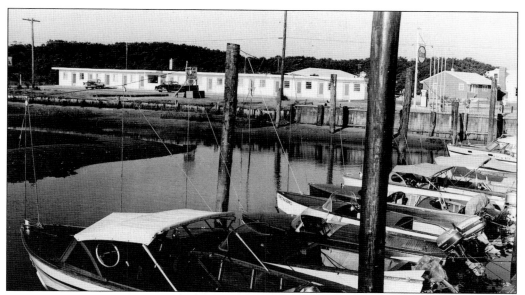

The Shark River Marina was begun about 1959 as a series of small docks for sailing boats and roundabouts. The operation grew to include three marinas in Monmouth and Ocean County. The Tides Motel was built next to the marina in 1950. The motel fell into decline and plans made in 1993 to develop it as a storage facility never came to fruition. It was finally condemned by the township and demolished on April 3, 1998. (Neptune Historical Museum.)

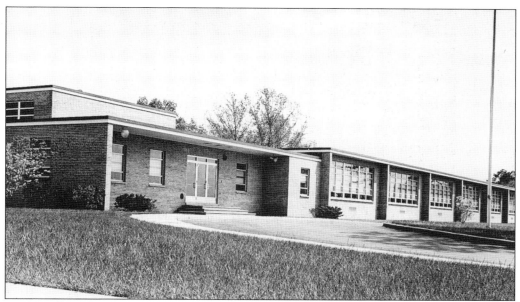

As the Hills residents shifted from mainly summer dwellers to year-round homeowners, the need for a local school arose. Students from Shark River Hills had attended Bradley Park Grammar School (1928–29), then Summerfield School until 1956. The Shark River Hills School No. 6 was opened in 1956 for grades kindergarten through eight, with Thomas Herbert its first principal. (Neptune Historical Museum.)

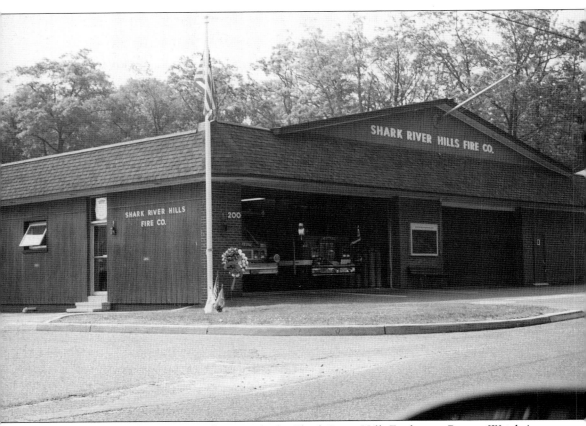

A breeze wafts the American flag outside the Shark River Hills Firehouse. Barney Wright's store on North Riverside Drive in the Hills hosted the first meetings of this fire company in 1928. The fire truck—a Seagrave Chemical truck—was kept there, as was the fire gong to be struck with a hammer to sound the alarm. The first regulation firehouse (above) at 200 Brighton Avenue was built in 1934, and was enlarged in 1960 and again in the 1970s. The original group of 15 volunteers has doubled in number since this fire company's inception. (Personal photo.)

The Shark River Hills First Aid Squad, 201 Carton Avenue, began service in May 1970 using a 1958 Cadillac donated by Wolfington Body Works of Mount Holly, New Jersey. Its first president was Don Wilkins, the vice-president was Dan Wilkins, the secretary was Roland Shumard, and the treasurer was Gerry Ryan. (Personal photo.)

BIBLIOGRAPHY

Asbury Park Press. May 3, 1998, Section H2, page 1.

Ayres, Shirley. *West Grove United Methodist Church: A History.* (unpublished manuscript), Bradley Beach, NJ, 1997.

Backstreets Magazine. Fall 1986, Number 18, Page 1.

The Blazer. Vol. 1, No. 1, Neptune High School, December 1942.

Boyd's Monmouth County Directory. 1917 and 1937. N.p., n.d.

Conlin, Joseph R. *The American Past, A Survey of American History.* San Diego: Harcourt Brace, 1984.

Eid, Joseph. *Trolleys in the Coast Cities.* N.p., March 1979.

Fiftieth Anniversary of Neptune Township New Jersey. Asbury Park Press: Asbury Park, NJ, 1929.

Goodrich, Peggy. *Four Score and Five, History of the Township of Neptune.* Township of Neptune, 1976.

Goodrich, Peggy. *History of Shark River Hills.* Neptune, NJ, 1963.

Goodrich, Peggy. *Ike's Travels.* Neptune Historical Society, 1976.

Lathrop, Elsie. *Early American Inns and Taverns.* New York: Tudor Publishing Co., 1926.

Lee, Francis Bazley. *Genealogical and Memorial History of the State of New Jersey.* Vol. 3, p.1115, Vol 4, p.1673. New York: Lewis Historical Publishing Company, 1918.

Martin, Geroge Castor. *The Shark River District.* Asbury Park, NJ: Martin & Allardyce, 1914.

McGilligan, Patrick. *Jack's Life: A Biography of Jack Nicholson.* New York: W.W. Norton & Co., 1994.

McKimm, James A. *The Friendly Church On the Hill, The History of the Hamilton United Methodist Church 1833–1983.* Chicago: Adams Press, 1984.

The Monmouth Democrat. August 14, 1868.

Neptune Township Committee Meeting Minutes, 1920. Township of Neptune Archives.

Ocean Grove Times. Vol. VI, No.11, p 1. March 12, 1898.

Past and Promise: Lives of New Jersey Women. The Women's Project of New Jersey. Metuchen, NJ: Scarecrow Press, 1990.

Salter, Edwin. *A History of Monmouth and Ocean Counties.* Bayonne, NJ: E. Gardner & Son, 1890.

Saturday Evening Post, "The Jumping Snakes of S.S. Adams" Issue 218, pp.26-27. June 1, 1946.

Stout, John B. *Early History of Neptune Township.* 1962.

The Wall Herald. August 19, 1982, p. 13.